The Pattern-Welded
BLADE
Artistry in Iron

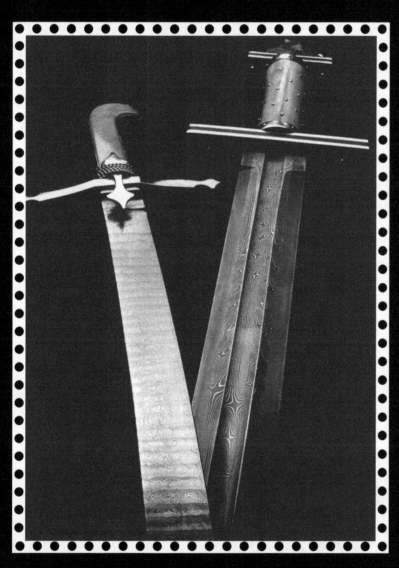

Jim Hrisoulas

The Pattern-Welded Blade: Artistry in Iron by Jim Hrisoulas

ISBN: 978-0-9987081-5-7

Contents

Preface

*T*his work is truly a labor of love. The information contained herein has taken over two decades to compile, develop, and, to some extent, perfect to the point where the desired results are not only obtainable but repeatable as well.

The quest for the perfect blade continues on its never-ending path. Yet with each success, with each barrier overcome, perfection is no nearer to this mere mortal. Each blade is a learning experience unto itself. When we quit learning, we in essence cease to grow in our skills and knowledge, and this, in a way, is far worse than one can imagine.

The pattern-welded blade is a challenge to the patience, ability, and inspiration of the smith. We all, at one time or another, have felt the inner fire of the steel, seen its soul birthed in the flames of the forge, given it power by our labor and sweat, and seen the beauty of our efforts come to life in our hands when we finished our first successful pattern-welded blade.

This work is dedicated to those who, like myself, have chosen the way of the forge as our own path. There are those who would discount our chosen avocation, scoffing at it as old fashioned, archaic, or simply a fad of nostalgia. But if you have the burning desire within your soul to pick up hammer and tongs and toil in an ancient art, then it is for you that this book is written.

There are no secrets in this art, only skills that have yet to be mastered. These skills are within the reach of any serious student of the forge, if the patience and discipline are there.

So it is to you, the sons and daughters of Tubal Cain, that this book was written. I have tried to set down all of my experiments and research on paper in a manner that can be understood and followed easily. Only you, my reader, will be able to tell if I have succeeded in my efforts.

I leave you with this: *Illegitimati non carburundum.*

Jim Hrisoulas, 1993

Acknowledgments

To those who have helped me in my studies, be it by purchasing my work or by simply listening to the ramblings on of a more than slightly demented bladesmith, I say thank you.

To Bob Engnath, the man who gave me the nickname "Demented Jim," thanks a lot, Bob. I *owe* you one for that.

To those ancient smiths who have gone before, those who have long since ceased to cast a shadow in this mortal world, I say thank you for your fellowship of spirit. I hope that my endeavors please you, for when it is my turn to pass from this mortal plane, I trust that you will welcome me into your midst, with forges glowing red and iron hot, ready for the smith's touch.

To my mother, I say thank you for letting me get started in this craft so many years ago.

And in closing, I would like to deeply thank my beloved wife, Trudi, who has stood by my side through all of the trials and tribulations of this haphazard existence we all call life. I love you, Trudi. Thank you for the years we have had, and for those yet to come.

Introduction

There have been many books written on the subject of forging blades, most of which simply do not cover the ancient art of pattern-welding iron and steel. A few go into the general process, while even fewer cover it with enough detail and information to allow for the serious student of the forge to actually make a laminated blade. This volume is dedicated solely to the pattern-welded blade.

This is not a "how to forge a blade" book. You should already know how. Rather, this is a volume for the advanced maker, one who already knows more than the basics needed to make a high-quality, good-looking blade. This book is for those who wish to expand their talents into the realm of the pattern-welded blade.

There are processes and techniques covered here that only the more experienced smith will be able to comprehend. If you are not familiar with these, then you simply will not understand the contents of this work. I suggest you look elsewhere for this information and then come back to this book.

There has been a lot of disinformation spread about how difficult it is to make a pattern-welded blade and how the process is accomplished in general. This book is meant to dispel the rumors and misrepresentations and let those who are interested find out exactly how to make a pattern-welded blade successfully, be it a simple lamination or one of the more complex, composite blades.

Granted, a pattern-welded blade is a lot of work. Hard, hot, sweaty work. But it is not impossible, as some would lead you to believe. Why these people do this I have no idea. Maybe they are insecure or ornery. Regardless, there is no real reason to be frightened of the process.

Pattern-welded blades have been made for centuries. The process was never "lost" or even rediscovered. The ancient bladesmiths made pattern-welded blades, as did German smiths working in Solingen during World War II for the presentation daggers given out by heads of state. As for today, there are more makers than ever making quality pattern-welded blades, and this alone should bolster your confidence in your endeavors.

These blades are beautiful, durable, and well worth the time, effort, and skills required to make them. They are the greatest attribute to a smith's skill, a skill that is well worth the patience, frustration, and tribulation involved in its mastery.

The Workshop

The workshop for the Damascus smith is more or less identical to a basic bladesmith shop. But there are some additional pieces of equipment that the majority of bladesmith shops do not have which, in my opinion, you will need if you are serious about making pattern-welded steel.

THE POWER HAMMER

The power hammer is perhaps the greatest labor-saving machine ever devised for the blacksmith. Power hammers come in all shapes, sizes, and designs. They can be mechanical or pneumatic. Mechanical hammers are the most common, while the more elaborate and expensive pneumatic hammers are easier to control and operate.

The older mechanical iron bangers are no longer being made, partially because they are capable of serious injury if operated improperly. But they were made by the thousands—tens of thousands actually—and there are quite a few still being used safely without injury or incident by blade-smiths around the world.

Mechanical hammers are inefficient and slow, yet they are the "standard" power hammers found in most shops. Even if they are considered obsolete, a lot of fine, world-class work is done under them every day. They are far more effective than any striker when it comes to moving metal. And maybe it's nostalgia, but there is "something" about using an old-fashioned iron smasher that the modern pneumatic hammers simply don't have.

Pneumatic hammers are very expensive, and this is a factor when considering tooling for the smith. Granted, they are very efficient and highly controllable in terms of stroke strength and length. In fact, the amount of control is amazing. They also allow for a more versatile strike, as the strength of the blow can be varied without slowing the speed of the strike as the power hammers do.

Regardless of the type of hammer used, they are highly recommended for the Damascus smith. I have two power hammers, both Little Giants—one a 25-pound machine and the other a 50-pounder. I use them both extensively, and even the small 25-pounder can do more work in an hour than I can in six. They are labor-saving devices beyond compare.

WARNING: You should already be familiar with the safe operation of power hammers. If not, I strongly suggest that you become so before attempting to use one. There are several references on the subject, and I suggest you study them prior to proceeding.

Safety is no light-hearted matter. It is up to you, the individual smith, to make certain that all safety procedures are followed every time you use a mechanical hammer or any other power tool. This includes face/eye protection, leather gloves, apron, and leathers. Leathers are a long-sleeved leather shirt used mostly by welders to keep sparks and welding berries off their skin and clothes. Because their impacts are quite severe, power hammers spray red-hot flux, slag, and scale in a 360-degree radius, so you must take the proper precautions or you may end up looking like a B-grade movie monster or worse.

In addition to the mechanical/electrical power hammers, there are several designs of foot-operated (manual) hammers available in preassembled and kit/blueprint form. I have used the design published by the Artist Blacksmith Association of North America (ABANA) and have found it to be very useful for most work. Foot-operated hammers can get a bit tiring when you are making a big billet, but for those who simply cannot or will not use a power hammer, they are a viable alternative. They do take some getting use to, as most designs do not allow for the use of dies. Rather, they require top/bottom tooling, and using this setup takes some practice.

TWISTING TOOLING

Twisting tooling is used to twist billets, blade core sections, and other pieces that will be incorporated into a blade later in the pattern-welding process, and it is an absolute must in the Damascus workshop. It can be as simple as a monkey wrench with an extra handle welded on or as elabo-

A common pipe or monkey wrench is easily modified to provide a secure hold by welding on an additional handle. (Photo by Gary Thompson)

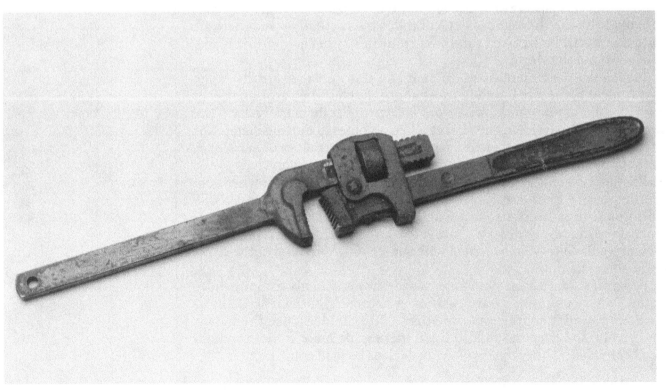

rate as an adjustable-jawed "T" handle. Regardless, one or more of these is required in order to make more than a few patterns.

You can also modify a pair of vise-grips (locking pliers) by welding an additional handle on the stationary handle, although I do not feel that it is in any way superior to the wrench shown in the photo. I have tried this modification, and it seemed that every time I tried to use this tool, the vise grips came undone. It was a bit troublesome to work with, to say the least.

There is another way to make twist/countertwist patterns, and that is to use a "twist jig" made from two pieces of square tubing and two adjustable wrenches, as illustrated in Figure 1.

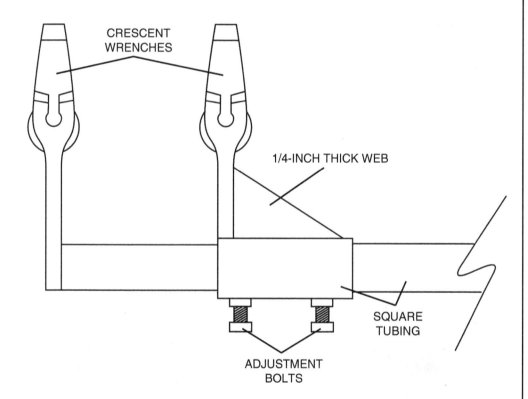

Figure 1. The twisting jig allows for even double-helix twisting of various pattern-welded materials.

The two pieces of square tubing must be sized so the smaller of the two fits snugly fit inside the larger. Weld the top (working) end of a wrench to one end of the smaller tube, as shown in Figure 2. Weld the other wrench head to the outside end of the larger piece of tubing (which should be no shorter than 6 inches in length), making certain that the opening is not obstructed. Also, make certain that the jaws open in the same direction and align in both planes so the piece will fit properly.

WARNING: Any welding operation should be conducted with adequate ventilation, and the welding of any plated metal should be approached with extreme caution. Common plating materials such as zinc, cadmium, and tin release toxic fumes at welding temperatures. If you scrounge iron piles for old iron, you may come up with lead or arsenic-plated iron, which can kill or at best permanently contaminate your work area. In addition, nearly all plating materials will only forge weld poorly, if at all.

Figure 2. When welding the wrenches on the twisting jig, make certain that the wrench jaws align in both the horizontal and vertical planes.

The twisting jig allows for uniform twist/countertwists to be formed simultaneously. Its adjustable length allows for a variety of twisted sections. (Photo by Gary Thompson)

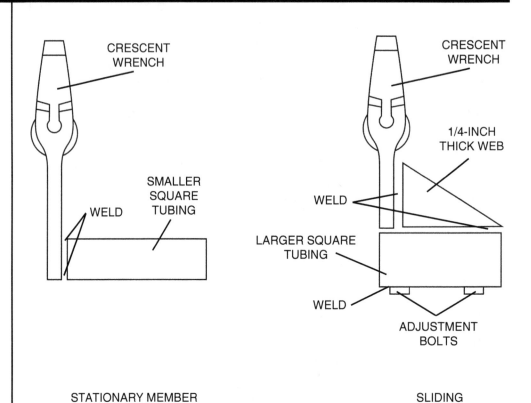

CRESCENT WRENCH

WELD

SMALLER SQUARE TUBING

STATIONARY MEMBER

CRESCENT WRENCH

1/4-INCH THICK WEB

WELD

LARGER SQUARE TUBING

WELD

ADJUSTMENT BOLTS

SLIDING MEMBER

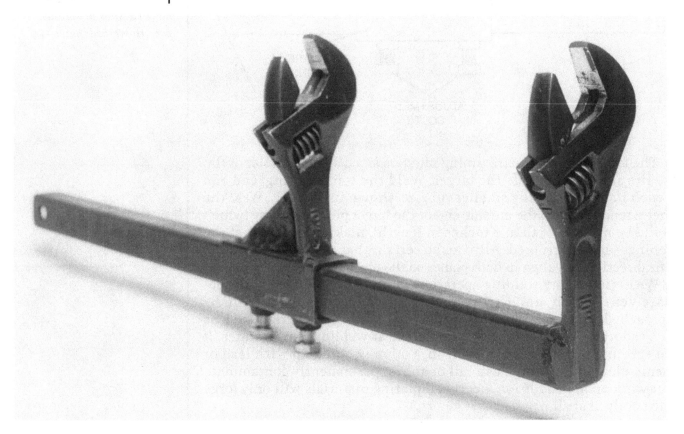

I have used 1-inch-square and 3/4-inch-square heavy wall tube for my tooling and have found that they work great.

For added strength, I suggest that you weld a 1/4-inch-thick "web" between the upright and the larger tube, making certain that the wrench's adjustment screw is still workable.

To allow for locking adjustments, weld two 3/8 x 16-inch nuts to the larger tube and drill and tap the holes on the bottom side of the slider.

I have found the twisting jig almost indispensable in doing traditional European-style pattern-welded sword cores. I will describe how to use this tool in Chapter 5.

BENCH VISES

The bench vise is also an absolute requirement, and one (or more) should be mounted very close to the forge to ensure a good, tight twist, as billet cooling can have a detrimental effect on the twisting rate. I suggest that this be a post (leg) vise, as you will be doing some hammering on it.

The more common machinist's vise is not designed to withstand this type of use very well; you can shear off the drive screw and that will end the life of the vise. The machinist vise is, however, a good all-purpose vise and is very useful for holding the work while you are filing, soldering, or doing most any other task other than forging.

SIDE VIEW

TOP VIEW

Figure 3. This pipe stand can be made to fit almost any PVC pipe. It's best to make it from 1/8 x 1-inch mild steel strapping.

Your machinist vise should be the largest and heaviest you can find. Also, make certain that it comes with replaceable jaws. This feature makes the vise more versatile, as extra jaws are easy to make and use. I have several different jaws made of smooth mild steel, smooth brass, knurled brass, and even leather to hold blades I do not wish to have marked.

ETCHING EQUIPMENT

Your etching equipment consists of two "tanks," one to do the actual etching in and the other to neutralize the action of the etchant. The tanks should be large enough to allow for a complete immersion of the area to be etched, with enough room to allow for circulation of the etchant around the workpiece.

For the tanks' materials, use anything that will not react to the etchant. This means either glass or plastic. I recommend PVC pipe sealed off with an end cap. PVC is available in a large selection of sizes. I have several tanks in various lengths made from 1 1/2-, 2-, and 3-inch-diameter pipe. This way I can etch just about any blade, ranging from a small dagger to a full-size Bastardsword.

You will need to build some sort of stand arrangement to hold the pipe sections vertical. This is easily made from iron strapping, as shown in Figure 3. Make at least two stands, one for each tank. This way you will be able to use a vertical etch, allowing for a long blade to be etched properly without taking up much space.

SAFETY EQUIPMENT

In addition to the standard eye/face protection, there are some pieces of equipment that should be considered an absolute requirement for the Damascus smith.

If you have yet to acquire infrared/ultraviolet-absorbing safety glasses *do so at once*. These are called dydidium glasses (sometimes referred to as Thermanon), and they are designed to block all of the harmful, eye-destroying radiation that is emitted from any heat source.

WARNING: *Do not* wear any glasses that have a dark tint like sunglasses or welder's goggles. These are not designed to stop radiation, only to cut glare and darken the field of vision to allow you to view bright objects. While this works safely for oxy/gas welding, it is totally unsuitable for forge welding. These glasses, due to their dark lenses, allow the pupil of the eye to dilate, and this in turn allows more radiation to enter the eye, causing damage or, in the worst cases, destroying your precious eyesight. I speak from experience; I came very close to having serious eye damage by doing just that. Your eyes are the only ones you have, so take care of them.

Another safety item is a full faceshield. While most faceshields are made of plastic, plastic isn't the best for heavy forging under a power hammer. It melts, becomes pitted, fogs up, and otherwise causes problems. There is a steel mesh faceshield available that, when worn over your dydidium glasses, allows for full face protection from the flying slag. The glasses protect your eyes from the radiation and anything that might

make it through the mesh shield. The mesh doesn't fog, and it allows for good visibility while affording excellent protection to your natural good looks. None of us wants to wind up looking like Frankenstein's monster. So the time to take safety measures is *before* anything unfortunate happens, not after.

With the lecture over, we can get back to the subject at hand.

FORGE AREA LAYOUT

Figure 4. General shop layout. All machines must have adequate working space.

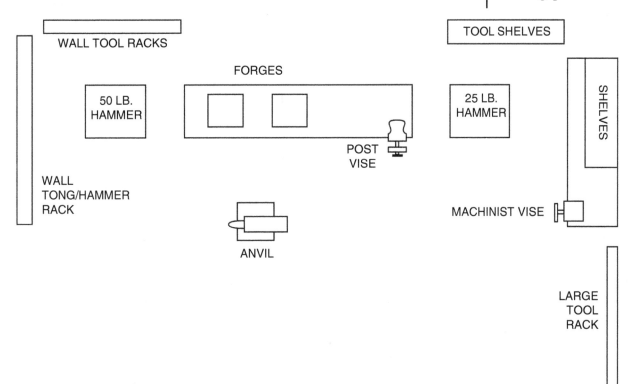

The most important layout is the forge area. The forge itself should be close to both the anvil and the power hammer. This way there will be no excessive heat loss while the work is being transferred. This is very important when welding, as the steel temperature drops very quickly, and you have on the average 5 to 7 seconds of welding time. You can do a lot of welding in that length of time, but it still isn't very long, so make the most of it.

I have my shop laid out as in Figures 4 and 5.

As you can see, the forge area is close but not crowded, placing everything within three or four steps. This way when I am welding, all I have to do is simply turn and I am at my anvil. A step or two to the left or right and I am at a power hammer or vise. Everything should be laid out with time and location in mind.

It is very important to have a good "working relationship" with your tools. Having everything in close proximity and at hand will allow for the maximum use of the time involved during the welding processes. As for the rest of the process, having the tools close is still an advantage, as the less time you spend looking for them, the more time you will spend actu-

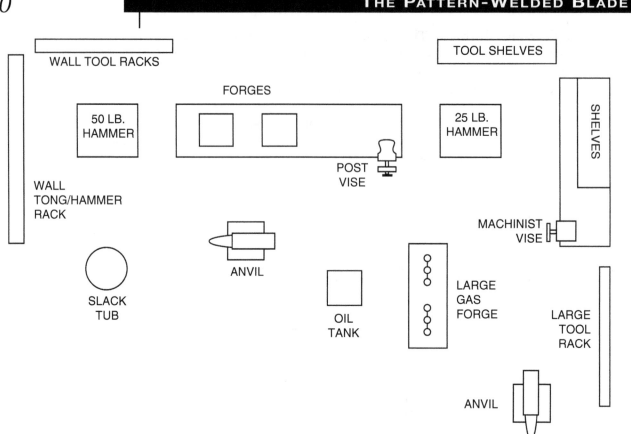

Figure 5. Forge area layout. All tooling is positioned close to the work area.

ally forging. Face it, the amount of time involved in making a Damascus blade is considerable regardless, so why make it longer by looking high and low for tooling?

As you can see, organization and neatness counts. A neat shop is a safer shop, and when you are working with a piece of steel heated to 2400°F, you need all the safety you can get. You have enough to worry about with the hot scale, flux, and other hazards of working with hot metal without having to deal with stumbling over equipment. Time and expedience should never replace safe working conditions. *Always* wear eye/face protection whenever you are working with any tool, be it hand or power, and always remember this old blacksmith saying: hand tools injure, power tools maim.

As stated before, these tools are in addition to the bladesmith tooling such as a good drill press, belt grinders, buffing/polishing equipment, and all the other gadgets and machines that seem to be so common among today's bladesmiths.

A well-organized and equipped shop is a pleasure to work in and a true mark of a professional. Add to your tooling carefully and learn to use them safely and you will soon find that you are not only working safer but faster as well.

Materials

A thousand years ago, the materials available to the bladesmith were limited to the steel/iron that he himself smelted. This was haphazard at best, as the quality of this raw material wasn't always as high as one would desire. Smelting iron from ore, even high-grade ore, is not an easy task. It takes a lot of time, an extremely high temperature, and considerable skill and experience to make even bloomery iron, let alone steel.

This is not the case in the modern world. We have at our disposal alloys of consistent quality, with various characteristics that are the same from piece to piece and melt to melt. What this means is we can have the same results in terms of hardenability, edge holding, toughness, and durability from blade to blade and bar to bar. Also, it is far easier to order a piece of carbon tool steel than it is to make one.

What alloy(s) to use? Here again, as with most things in this craft, it is up to the individual smith to choose which steels he cares to utilize in the making of a pattern-welded blade. Some combinations of steels result in a very subtle pattern, while in others the watering is vibrant and "jumps out" from the blade.

The alloys and materials described below are only some that are available to the bladesmith. This should serve only as a guide in selection. Although I have my personal favorites, my feelings shouldn't be the deciding factor for your choices.

To help you obtain the same alloys that I describe below, I have included the specification numbers.

HIGH-CARBON STEELS

The reason that a pattern-welded blade is so tough is the fact that one half of it is soft, unhardenable iron/mild steel while the other half is a higher carbon steel that will take and maintain its edge. It is this balance that has given the pattern-welded blade its fine reputation over the centuries. Up until a few years ago, it was the top material for blades to be forged from, but in today's world, with all of the ultrahigh-tech alloys, this is, sadly, no longer true. Regardless, you must start with a good high-carbon steel if you want to end up with a good blade when everything is done.

10xx Series Steels

I will start out with my old standby, the 10xx series steels. These are perhaps the finest all-around knife steels available to the bladesmith in terms of versatility and general use. While they are "simple" carbon steels without all of the fancy ingredients that other steels have, they offer the smith a very broad working range, are easy to weld, and resist overheating quite nicely, better than most of the richer alloys so commonly used by today's smith.

Any of these 10xx series steels will weld into a fine blade, but unless you use an alloy that contains some chrome, nickel, or other elemental differences, the watering will be based on carbon differences only and hence will be very subtle.

I have yet to encounter any difficulties in welding any 10xx series steel, and they work so nice under the hammer.

10xx series steel contain the following:

> 1060: Spec # ANSI/ASTM A 576 (1060)
> (aka "Plowshare Steel")
> C: 0.55%-0.65%
> Mn: 0.60%-0.90%
> P: 0.040% max
> S: 0.050% max
>
> 1075: Spec # ANSI/ASTM A 29 (1075)
> (aka "Improved Plowshare Steel")
> C: 0.70%-0.80%
> Mn: 0.40%-0.70%
> P: 0.040% max
> S: 0.050% max
>
> 1084: Spec # ANSI/ASTM A 29 (1084)
> (aka "Extra Improved Plowshare Steel")
> C: 0.80%-0.93%
> Mn: 0.60%-0.90%
> P: 0.040% max
> S: 0.050% max
>
> 1095: Spec # ASTM A 108
> (aka "Extra-Extra Improved Plowshare Steel")
> C: 0.90%-1.03%
> Mn: 0.30%-0.50%
> P: 0.040% max
> S: 0.050% max

All 10xx series steels harden in oil, but if severe carbon migration occurs, you may need to harden in brine. (See Chapter 8 for further information.)

5160

5160 (Spec # ASTM A 689) is a very tough steel that has *excellent*

working abilities, but it is prone to oxidize (scale) so a neutral to slightly reducing atmosphere is best when welding. It produces nice contrast and is very forgiving when overheated. It is a good choice to laminate with 1010 or other low-alloy steel.

5160 should be oil-hardened only. It is best when tempered to approximately 53 Rc to 55 Rc.

5160 contains:

C: 0.56%-0.64%
Mn: 0.74%-1.00%
Si: 0.15%-0.30%
Cr: 0.70%-0.90%
P: 0.035% max
S: 0.040% max

52100

52100 (Spec # ASTM A 295) is a newcomer to most smiths and is usually found in the form of recycled roller mill balls. It is hard to find in bar form, but is does make for a very vibrant pattern, although it is prone to be a little red short. It can also be a little difficult to weld due to the molybdenum content, as well as a little red hard.

Scaling is a bit heavier but not as bad as L-6. It is a very good steel for the more advanced student, and it makes a decent blade when welded with a mild steel (1010/18).

52100 contains:

C: 0.98%-1.10%
Mn: 0.25%-0.45%
P: 0.025% max
S: 0.025% max
Si: 0.20%-0.35%
Cr: 0.90%-1.15%
Ni: 0.25%
Mo: 0.08%
Cu: 0.35% max

O-1

O-1 (Spec # ANSI/ASTM A 681) is one of old standards used for pattern welding. I do not care for this alloy particularly, as it is severely red short and does not withstand overheating very well. It can fracture, grain separate, or crack at the worst possible time, but some smiths love this steel.

O-1 does forge a good blade all by itself, but I feel that it is not the best choice for a laminated blade due to its red short problems.

O-1 contains:

C: 0.85%-1.00%
Mn: 1.00%-1.40%
W: 0.40%-0.60%
Cr: 0.40%-0.60%
V: 0.30%

O-1 is an oil-only hardening steel and, when properly heat-treated, can make a very good blade. I suggest that you laminate this material with a simple alloy mild steel or a richer alloy tool steel such as L-6. When used in this manner, carbon migration is nonexistent.

L-6

L-6 (Spec # ANSI/ASTM A 681) is a chrome/nickel alloy steel with excellent toughness and shock resistance. It is a medium-carbon, oil-hardening alloy with excellent working characteristics. It will withstand some severe flexing and is a very tough laminate. L-6 can be very vibrant in contrast due to its makeup.

L-6 is somewhat hard to find, but it is available. It has been employed mostly for industrial lumbermill band saw blades, and these are a good source for this material.

L-6 contains:

C: 0.65%-0.75%
Mn: 0.30%
Cr: 0.60%-1.20%
Ni: 1.25%-2.00%
Mo: 0.35%
Si: 0.50%

L-6 works easily under the hammer, but it is prone to heavy scaling and oxidation. This material is best when used with a 10xx series steel (you can use either a low-carbon or a higher carbon 10xx series, as the watering will be due to alloy differences, not carbon content alone). You can also laminate this steel with O-1, which does produce some contrast, though not as vibrant as if a 10xx series was used.

W-1

W 1 (Spec # COPANT 337 W-1) has been around for a very long time both in the custom knife industry and the manufacturing world. It is a very simple alloy that is water hardening (hardens nicely in oil too). It is also a shallow hardening steel that can be laminated with 1018 for traditional Japanese-style construction, although it can be red short.

W-1 contains:

C: 0.60%-1.40%
Mn: 0.15%
Cr: 0.15%
P: 0.03%
S: 0.03%
Si: 0.10%-0.35%

W-2

Like its brother W-1, W-2 (Spec # COPANT 337 W-2) is another old-timer. It is tougher than W-1 and is less prone to cracking and warpage. W-2 is a water-hardening steel that can respond nicely to an oil quench, and here again it is a shallow-hardening alloy that welds very well to most other materials. It can be red short.

W-2 contains:

> C: 0.60%-1.40%
> Mn: 0.15%-0.40%
> Cr: 0.15%
> V: 0.03%
> P: 0.03%
> S: 0.03%
> Si: 0.10%-0.35%

LOW-CARBON STEELS

Nearly everyone has covered the high-carbon alloys, but there has been little discussion of the lower-carbon alloys that are available to the bladesmith, which I refer to as "color" steels. These alloys not only give toughness but great contrast in the pattern as well.

While most of these steels do not contain enough carbon to harden well, they should be covered for the pattern-welding bladesmith because some of them can be very tricky to forge-weld effectively.

I feel that I should start out with the old standby: cold-rolled mild steel.

1018

1018 (Spec # ANSI/ASTM A 576) is very common in both hot-rolled and cold-rolled steel. 1018 is also referred to as structural iron, mild steel, and numerous other names. It works very easily, although it can cause severe carbon migration when laminated with higher-carbon alloys. It is very forgiving and will withstand severe overheating.

1018 contains the following:

> C: 0.15%-.23%
> Mn: 0.30%-0.60%
> P: 0.040% max
> S: 0.050% max

This material will weld to most anything, especially a higher carbon content 10xx series. It will cause carbon migration, so care should be taken to ensure that working temperatures are not high enough (in the bright orange/yellow ranges) to allow this to happen.

Since there is little carbon content, 1018 steel will not harden on its own, and it is what I consider a "neutral" material, as there are no alloying elements such as chrome, nickel, or anything else that could affect the action of the etchant. If this material is welded with a richer, higher-carbon alloy such as O-1 or 5160, the watering will be better than if 1095/84 is used.

A 203 E

A 203 E (Spec # ANSI/ASTM A 203 E) is a mild steel with a considerable amount of nickel, but not enough to render it a stainless steel or to cause any problems in welding. It is best used as a color steel in conjunction with a simpler high-carbon steel such as 1095/84, W-1, W-2, or WHC

steels. It does not contain enough carbon to harden on its own, and it can cause carbon migration if the proper forging techniques are not followed to prevent this from occurring.

A 203 E is available in plate form only, so this material will have to be cut from heavy sheet (1/4-inch/5mm is the minimum thickness usually available) into usable strips before starting to laminate.

A 203 E contains the following:

C: 0.20%
Si: 0.13%-0.32%
Ni: 3.18%-3.82%
P: 0.040% max
S: 0.040% max

A 203 E can withstand some minor overheating, but it does scale heavier than a simpler alloy mild steel. It results in more vibrant watering due to the nickel content.

WROUGHT IRON

Wrought iron is perhaps the most traditional low-carbon material that can be used for pattern welding. It is no longer being made, with production having ceased in 1963. It was also known as bloomery iron and sponge iron after the methods of manufacture.

Wrought iron is semirefined iron with a considerable amount of silica slag in its composition. It has a "stringy" fibrous structure, and it is a gem to work with. It welds easily and contains a very small amount of carbon and nothing else.

Most wrought iron material available today comes from salvageable scraps such as old boiler plate, fencing, and other antique sources. All of the wrought iron that I have came from an iron fence made circa 1880. I use this material sparingly.

Wrought iron will not harden, but it can cause carbon migration, so this must be taken into account when working with it.

PURE NICKEL SHEET

While this isn't exactly a steel per se, it can be used for some downright dramatic patterning. Since the nickel is unaffected by most etchant processes, the mirrorlike surface of this material remains brilliant, while the other materials used are etched away slightly, darkened, and dulled. This makes for a very robust and easy-to-see pattern.

But this does have its price. Pure nickel sheet is very expensive, with prices ranging from $12 a pound on up! It is also a "picky" material in terms of working, and it will alloy with the steel and wash out the pattern if you laminate too finely. I get best results with approximately 175 to 300 layers per blade, depending upon the pattern involved.

Since nickel sheet does not form carbides, it will not cause carbon migration. While this is good, it does not produce a first-class cutting edge. I strongly suggest that this material be used for center cores in a composite blade such as traditional Viking/European blades or some

other style that allows for a higher-quality edge material to be employed. Also, nickel sheet does not do well when twisted extremely heavily. You can twist it, but not to the extent of a mild/high-carbon steel laminated billet.

Despite its drawbacks, I love this material, as the patterns simply jump up off of the blade.

RECYCLED MATERIALS

While I am not all that enthusiastic about using recycled materials due to my personal belief that a first-class blade should be made from first-class materials, I do use them from time to time, mostly for the uniqueness of what they started out to be, like a plowshare beaten into a sword or a gun barrel made into a knife. But there is an almost endless supply of reasonably good material out there, and you should at least know what material it is made from.

Recycled Items	Material
HSS tool drill rod	M-2 (usually)
Leaf springs	5160 or 1060
Bearing races	52100
Ball bearings	52100
Old files	W-2 or 1095
Plowshares	1060 or 1084
Automotive axles	1045
Baler tines	1045 or 1060
Lumbermill saw blades	L-6
Planer blades	F-8
Jackhammer bits	S-7

This is only a small sampling of what is out there as far as recycled materials go, as the complete list of available material is too long to go into. Like I stated before, I suggest that you use only new materials, as then you know exactly what you are getting, and there is no doubt how to work, harden, or use a specific material or alloy.

MATERIAL THICKNESS AND ITS EFFECT ON WELDING

There seems to be a sudden interest in using thinner materials in the building of the starting billet. Since 1978, I have been using very thin (0.003 to 0.005 inch) high-carbon steel shim stock welded with either a pure nickel shim or low-carbon shim stock, and I have had excellent results in doing so. There is a slight problem with holding the billet together, as materials of this thickness tend to warp heavily when introduced into the atmosphere of a burning forge. This is remedied by simply sandwiching the shim stock between two pieces of either 1/8- or 3/16-inch-thick stainless-steel bar stock and wiring the assembly together tightly like any other billet. (It is possible to arc/gas weld the ends together, but I state my personal prejudice against this in the next chapter.) You

use stainless steel because the stainless should not weld to the billet, allowing for only the carbon-steel laminates to weld, which prevents any thicker layers at the surface.

The advantages of using shim stock is in the fact that the more layers that you start out with, the less welding you will have to do. If you weld, say, 250 layers for the first weld (I have welded upwards of 350 and had excellent results, but it did take some practice), you can go from the first weld and forge the billet into a blade, or you can simply fold once and have approximately a 500-layer count, which gives a very fine pattern, without having to cut, weld, forge, cut, weld, forge, etc., three or four more times.

Doing this will cut down on time considerably, but there is another advantage, especially if you are planning on doing a complex composite pattern. The less you have to draw out the steel and reweld, the less distortion you will have in the layers. This means that the laminations will be more even prior to patterning, and even laminations are very important if you want the best results in the finished piece.

The evenness and uniformity of the pattern is the mark of a careful and skilled craftsman. The so-called random-pattern Damascus is a straight laminated bar that is, in my opinion, simply slapped together with little regard for the consistency of the pattern in the billet. Most of the commercially available bar stock is made in this manner. There is no reason why the laminations cannot be made straight and even, and this is what you want when you are making specific patterns.

Regardless, the number of layers that you start out with will dictate the amount of welding and forging you will need to do in order to get the desired number of laminations in a given piece.

Mostly you will find that the standard rolled mill thicknesses of 1/8, 3/16, and 1/4 inch are what are readily available in both high-carbon and mild steels. I have no problem in using any of these, although I do lean a bit toward the 1/8 inch because it allows me to weld at least 15 layers on the first weld.

Forge Welding

The basis of the pattern-welded blade is the forge weld. Forge welding, when properly done, is far superior to any other weld. It is an absolute perfect weld without any type of filler or added material that can present problems.

Before one proceeds further, one must first understand the processes involved in forge welding. This way you will have a working knowledge of what is going on while you are welding.

The most basic description of forge welding is this: get the piece hot, flux it to keep the weld surfaces clean, return it to the fire, get it up to a welding heat, then remove it from the forge and strike it lightly with a hammer. Sounds too easy, doesn't it? Well, once you get used to forge welding, it is easier than it sounds. As a matter of fact, you will find that the more welding you do, the easier it is. The old adage "practice makes perfect" applies wholeheartedly to forge welding.

While I can explain the processes in print, there is nothing like first-hand knowledge. While this is not always feasible, it is a good idea to pursue. Short of that, I will try to explain how to forge weld.

The first subject at hand is material preparation.

The condition of the material is important, as the surfaces must be clean and free of all mill scale, rust, waxes, oils, and other impurities. Also, the surfaces must be smooth or you can run the risk of trapping flux, scale, or other materials in the weld seam, causing a "slag inclusion" that is unsightly at best.

The best way to make certain that the surfaces are prepared properly is to grind them shiny with a 50- or 80-grit belt. Make certain that the grit lines run at an angle to the edges of the piece, not parallel along the length. This way, the grind marks will help the flux to penetrate the weld surfaces. This penetration is very important if the welds are to be successful and sound.

Grinding the surfaces may seem like unnecessary work, and some makers simply pass on this, but I feel that if you start out with a clean surface, the less work there is for the flux to do, and the less flux used, the better.

The surfaces should meet closely and as flat as possible. Some smiths recommend grinding a dome shape on the pieces, thinking that this taper-

LOW CARBON

HIGH CARBON

Figure 6. The "doming" of laminates prior to the first weld.

ing will aid in the welding. To me it simply presents a larger gap for stuff to get trapped in, and that is a problem if it happens.

I have been pattern welding for many, many years, and I have found out through decades of experimentation that the closer the surfaces are together, the better the welds turn out. These surfaces must be tight, close, and clean for a good weld. This is easy to do, takes only a small amount of time, and in my opinion makes for a better weld.

With the surfaces prepared, you can assemble the billet.

The size of the billet depends on several factors. One is your forge size. This is very important, as the bigger the piece to be welded, the bigger fire you will need. You wouldn't want to try to weld a 2 x 2 x 14-inch billet in a small coal forge. It simply wouldn't happen. A good size for the neophyte is 1 x 1 x 8 inch. This is a nice-size piece to start with, yet it isn't so big as to be a problem in heating or handling. I weld anything from 1 to 1 1/2-inch square up to 24 inches long. The larger sizes are a bit difficult to manage, but I am using a power hammer and I make a lot of pattern-welded steel blades. But back to the subject at hand.

Another limiting factor with regards to your billet size is the material you are using. If you are using standard mill-sized bar stock, then you can work with most any standard size. But if you are using random-sized materials, you may have difficulty stacking the billet, so you may need to cut your own sizes from either sheet or bar.

I use shim stock for most of my welding, so I cut from a larger sheet and then make my billet. This is time consuming, but I find that it gives me more control of the pattern (more on this later).

For the sake of example in this chapter, we will assume that you are using standard mill-sized barstock in 1095/1084 high-carbon and 1010/1018 mild steel, 1/8-inch thick, 1 inch in width, and 8 inches long.

You will need eight pieces of mild steel for the starting billet. It is best to learn to weld on the more difficult mild steel then to attempt to weld the more expensive high-carbon steel. Once you master welding mild steel to mild steel, it is a simple matter to learn to weld high carbon to mild steel (more on that later, too). For now we will be dealing with the mild steel.

Clean the surfaces and stack the pieces. With the pieces in position, clamp the billet together and grind the edges even. Once the edges are even, place the billet in a vise, remove the clamps, and secure it prior to the first weld.

There has been some controversy as to the best way to go about this. Some makers weld around the edges with either a gas or arc welder, while others suggest that you drill a hole through the layers on both ends and bolt them together! To me, either one of these methods is totally ridiculous. The welding will introduce filler rod and/or flux contamination that can be detrimental to forge welding, and the bolting technique will simply be wasting the area at both ends.

I suggest that the pieces be wired together with a heavy wire (bailing wire is excellent for this), as shown in the photo. This wiring allows for easy examination of the welded layers and easy application of welding flux. Once one end is welded, the wire is cut free and the welding process is continued.

The prepared and layered billet is wired together prior to the first weld. The wires will be clipped off as the welding proceeds down the length of the bar. (Photo by Gary Thompson)

When you are wiring, make certain that the layers do not shift and that the wire is as tight as possible. Use the double wrap as pictured in at least two places (more on longer billets) to keep the layers in the proper position.

With the billet wired, you are ready to proceed with the welding process.

The next topic is the heat source. This can be a coal- or gas-fired forge. It must be able to reach and maintain a welding temperature (2200°F+) with an even heat and without any cold spots. For some combinations, a gas-fired forge is best due to its cleaner-burning fire.

The coal forge is the "traditional" forge for the bladesmith. They are very dirty, hard to maintain with a clean welding fire, and take considerable experience to get sound, clean welds with. But they are very versatile for a plethora of uses and present a variety of heating ranges that a gas forge cannot compete with.

I have used a coal fire for many years and for some work I prefer it over the gas. But they take time to learn to use; proper fire tending is a skill that can only be acquired by many, many hours of use. But by now, you should be more than familiar with the basic fire practices of bladesmithing, so I do not have to cover the fundamentals of fire building, open/closed fires, or other techniques of the beginning bladesmith. We can delve right into the welding techniques using a coal fire.

WELDING IN A COAL FORGE

Welding using a coal fire has been done successfully since the dawn of iron working. It does require skill, a good hand, and a good deal of experi-

ence. The number one factor to consider is a clean-burning fire. A clean fire—one that is free of green coal, clinkers, and other impurities—is mandatory if the weld is to be clean, sound, and successful.

You can use either a closed or an open fire. I prefer to use the open fire for most welds, as I feel that it gives me more control over the process than the more traditional closed fire. But personal preference on your part should be the deciding factor as to which fire you use.

With the fire clean and burning steady, place one free end of the billet into the fire, edge up to allow for the heat to rise between the layers. If you place the billet flat down into the fire, the lower layers will heat first, and this will cause nothing but problems when a weld is attempted. In fact, it is not uncommon for the lower layers to burn before the upper layers are even up to temperature.

As the billet heats, use a slow, even blast. A slow blast means a slow heat, and that is what's needed. This allows for the heat to soak into the layers without overheating the outer pieces.

When the piece is at an even, full, cherry-red heat, remove it from the fire and flux. You will need to apply the flux to the edges of the billet, allowing it to melt down between the layers, covering and cleaning the weld surfaces. Apply a light coating to the flats as well. (For more on flux, see page 24.)

With the piece fluxed, return it to the fire and continue to heat. When the piece is again at a full cherry red, bring the blast up slightly to increase the heat. When it is at a bright orange, again increase the blast slightly until it is at a full yellow. This is the proper welding temperature for mild-steel-to-mild-steel welds. The piece should also be hissing slightly, with a few sparks coming off of the surface.

When the billet is at the proper heat, remove it, quickly place it flat down on the anvil, and strike it lightly with the hammer to start the weld. There will be considerable spray, so be careful. Continue the blows until the piece drops below the welding temperature. Make certain that you overlap the blows so the entire area is welded.

When the first area is welded, flux the next area, return to the fire, and slowly reheat until the piece is again at a welding temperature. You will need to overlap the weld areas by approximately 25 percent to ensure a sound, complete weld.

You will need to hammer the welds quickly, as the temperature of the piece drops quickly, limiting the working time. As you work your way down the billet, you will find that you will be able to "feel" the weld take. This is a nice sense to develop if you are planning on doing a considerable amount of pattern welding.

When the entire billet is welded, I suggest that you go back over it with another complete welding sequence to ensure that the welds are sound. When this is completed, let the billet cool slowly before proceeding further.

When the piece is cool, grind the edges smooth and inspect the welds. If all went well, you should see nothing but smooth, shiny metal, with no signs of any layering or anything else to suggest that the piece is not a single bar of steel.

Any black lines are "cold shuts," or areas where the welds didn't take. If these exist, simply place the billet back into the fire and reweld

the affected area, making certain that the piece is up to heat for its entire thickness.

When you have mastered welding mild steel to mild steel, feel free to move on to the more difficult-to-weld high carbon to mild steel.

WELDING IN A GAS FORGE

Gas forges are very clean, quick to get to a welding heat, and require no fire maintenance once the atmosphere is set. They do not allow for the fine control of local heat, nor do they give the general control of temperature that a coal fire does. Yet when you compare the amount of time saved by not having to tend the fire, these inconveniences are minor.

If you are accustomed to a coal fire, using a gas forge to weld in takes some getting used to. Once you get use to it, however, it is actually easier to weld in a gas forge.

Prepare the materials the same as in a coal fire, making certain that the weld surfaces are clean (this is very important in a gas forge) and tight. This makes for an easier weld. With the billet prepared, you are ready to proceed.

Light the forge and get it up to heat. You will need at least a 2250°F interior temperature to get a sound weld. The atmosphere that you want is neutral to slightly reducing. What this means is that there is no excess oxygen in the forge interior that can cause problems, ranging from excessive scale to heavy oxidation and carbon runs.

When the forge is up to heat, you can tell the proper atmosphere has been reached when the interior is a bright orange/yellow and a yellow flame is extending approximately 3 to 5 inches out the door. This flame is the unburned propane from the inside of the forge, making the atmosphere inside reducing.

WARNING: If you smell propane gas at any time the forge is running, cut the amount of pressure to the forge. There is far too much fuel going into the forge for it to burn safely and operate normally. You can hurt yourself in a very short period of time if you do not cut the fuel back immediately. Serious injury by explosion, burns, or asphyxiation can result if you do not follow this safety note!

If this does not curtail the smell of gas, you have a leak somewhere that must be dealt with immediately. Turn the forge off *ASAP* and turn off the gas at the tank to prevent any additional gas buildup. Air out the area completely. The amount of gas that can build up in a small area, even in a short period of time, can be enough for a fire or, worse yet, an explosion.

When the area is aired out and the forge is cooled down, turn the gas on at the tank, leaving the forge gas inlet turned off, and check for leaks along that hose. To do so, use soapy water and look for bubbles at all joints and junctures. Whatever you do, *never use a match*. You can become a bunch of small flaming bits rather quickly if you do. Flammable gas can be very deadly if ignited in a small area such as a workshop, so make certain that all connections are leak free and all hoses are free of holes and cracks that can lead to leakage. Remember—it is easier to prevent a problem than to have to deal with an explosion.

With the forge preheated, insert the billet into the fire box, placing it in on its edge (layers running vertical) so the end gets the most heat. You will have to turn the billet every minute or so to ensure a steady, even heat. Let the heat soak into the billet. When at a full cherry red, remove the billet and flux lightly. You do not need to drown the piece in borax for it to weld. In fact, you only need enough flux to cover the surface lightly, far less than when using a coal fire.

With the piece fluxed, return it to the forge and continue to heat. As the piece is heating, rotate it in the fire to ensure an even heat and to keep the flux from running off.

As the temperature rises, the flux will first coat the piece, but when the welding range is reached, it will look like hot honey on the surface, and it should start to bubble and hiss just a little. The billet should be a bright orange/yellow at this time. When it is, remove it and quickly place it on the anvil, flat down. You should already have the hammer in your hand and the blow started by the time the billet is in place. Strike the end of the billet and set the weld. Again, you should be able to feel the weld take.

When the end is started, proceed to weld the adjacent area. You will have approximately 3 to 5 seconds to do so. When the piece falls below the welding temperature, lightly flux the next area and return to the forge to get back up to heat. You will be working in small areas, large enough to weld approximately 2 to 3 inches at a time. This way you will not be overheating the billet as you are working. Also, overlap the welded areas to ensure a sound weld.

Work your way down the length of the billet, welding and fluxing as you go. When completed, start again and go back over the entire length of the billet just to make certain that the welds are sound.

When this is done, you should have a solid bar. To check the welds, let the billet air cool, then grind the edges clean and smooth and examine closely. You should see nothing but bright shiny metal. If there are any fine black lines—unwelded layers known as "cold shuts"—return the billet to the forge, bring it up to heat slowly, and flux the affected area at a full cherry red. You want the black lines up so the flux will better penetrate down between the layers.

When the piece is again at a welding heat, reweld that area, making certain that the welds take. Reweld all affected areas at this time. This should remedy the situation.

Practice on the mild steel until you are confident about your welding abilities using a gas forge before proceeding to the more costly high-carbon steels. This way you will have some experience at welding before you try the more difficult higher-carbon alloys. These steels introduce their own unique problems to the process.

FLUXES

This is another subject that has had its share of controversy. It seems that there are some makers out there who claim to have the "ultimate super flux" or some secret ingredient that makes welding almost as easy as simply looking at the pieces. In all the years I have been doing this, I have found

nothing that works better than plain old anhydrous borax with a little sal ammoniac thrown in (10 parts borax, 1/2 part sal ammoniac).

Anhydrous borax is simply common, everyday household laundry borax (get the plain borax, *not* soap with borax) with all of the chemical water boiled out of it. It may look and feel dry to the touch, but borax contains a considerable amount of water that has to be removed before you can use it.

To remove the water, heat the borax until the water boils off and the borax melts. This does require a high temperature (in the 1700°F range) to do this.

I use a sheet metal (unplated) lead pot used in reloading. Borax is very corrosive, and the pot will need to be changed regularly or else the borax will eat its way through the bottom. Simply fill the pot a quarter to a third full and heat it in the forge. It will start to foam up and steam, becoming sticky and then melting into a thick liquid.

WARNING: *Be very careful!* Molten borax is very corrosive, and if it splashes on you, it can cause serious burns and/or disfigurement. *Wear adequate protective clothing!*

Add more borax until you get the pot half full and return it to the heat. When this fresh borax is melted, remove from the forge and add more until the pot is again half full and return. Continue this process until the pot is filled halfway with liquid borax.

Next, pour the borax out onto a smooth, clean, *dry* iron or steel plate (I have a 1-square-foot plate 3/8-inch thick that I use for this). It will pour like thick honey. Allow to cool. While cooling, the borax will chill, craze, and then crack into smaller pieces. This is normal and even desired, as the next step is to grind it into a powder. Right now it should look like black glass.

When cooled, grind the borax in a mortar and pestle until it is powder and then add the sal ammoniac. Mix well and you are ready to use. Keep the borax sealed tightly and dry or else it will start to absorb moisture from the surrounding air, and that will cause it to bubble up and foam when applied to a hot piece of steel.

There are various commercial fluxes out there that contain all sorts of things that I think will result in problems. Mostly, these fluxes contain iron or steel shavings that can be very detrimental to a clean weld. I feel that the addition of any sort of foreign material to the welding process such as metal filings increases the chances of problems in the weld. I suggest that you stay away from any forge welding flux that contains any sort of metal shavings.

NOTE: The fluxes used in welding are very corrosive to the refractories used in the lining on a gas forge. To prevent the flux from eating its way through the sides or bottom of the forge, place a slice of kiln shelf (available from ceramic hobbyist suppliers) on the bottom of the forge to catch the drips and prevent them from getting to the forge lining. This shelf can be cut easily with a stone mason's (brick cutting) blade in a hand-held circular saw. Make certain that you wear a respirator and eye protection. The inhalation of any sort of silica can lead to silicosis, also known as "grinder's consumption," which is not curable, and it is cumulative. So prevention is the key. Why take a chance on your health and life?

My Own "Secret Flux"

I am constantly looking for ways to improve the welding process, and one of the ways to do so is to improve the flux. When the flux works better, the weld is easier.

Flux should not only be able to coat the surface to protect and clean it, but it should also penetrate deep into any voids, open spaces, or cold shuts. While anhydrous borax makes a fantastic welding flux, it doesn't always penetrate as well as needed. This can result in cold shuts, weld flaws, or flux/slag inclusions.

I have had excellent results using a liquid flux as a "pre-flux" applied prior to the piece being placed into the forge. This liquid flux is simply a supersaturate solution of common borax, like that used to make the welding flux mentioned before. Heat up some water until it boils and start adding borax, making certain that it dissolves. Then mix in more borax, dissolve it, and repeat this process until no more borax dissolves in the solution. When this is complete, you have your liquid flux.

Simply dip the piece to be fluxed into the solution, remove it, and warm it gently until the water steams off. This will leave a nice coating of borax on all the surfaces, ensuring good penetration of the flux into even the smallest and tightest spots in the billet.

With this accomplished, place the fluxed piece into the forge, bring up to a cherry red heat, apply a little dry flux to protect the outer surfaces, and proceed with the welding process.

I have used this combination of fluxing for more than a few years now, and it does work in keeping the weld surfaces clean, and that makes for an easier weld.

PATTERN WELDING

When you feel confident about your abilities to weld mild steel, you are ready to attempt to weld high-carbon steel and mild steel combinations. Here again, for these billets you will be using 1/8-inch-thick, 1-inch-wide steel bar stock, 8 inches long, in both 1018 and 1095.

Pattern Welding in a Coal Forge

You will need to prepare the pieces a little different then before. You will need nine pieces: five of 1018 and four of 1095. Grind the surfaces smooth and clean and then make your billet, with the 1018 on the two outside layers, as shown in Figure 7.

The reason for placing the mild steel (1018) on the outside of the billet is due to the fact that this material will withstand a higher temperature than the higher carbon 1095. This way, if the two outer layers get a bit overheated, there will be little if any damage to the billet.

Overheating and too rapid heating are the two most commonly encountered problems in welding in a coal forge. To prevent these problems from occurring, bring the temperature up slowly, and constantly rotate the billet 180 degrees to keep hot spots from becoming a problem.

To start the heating process, place the billet into the fire edge up. This way the billet will heat from the edges up, not from the flats in, which allows for the heat to rise up between the layers, heating them a bit more

LOW CARBON

HIGH CARBON

Figure 7. When welding in a coal forge, place the low-carbon layers on the outside to prevent layer burning.

evenly. Again, take this heating process slowly, regularly rotating the billet 180 degrees to prevent overheating the layers.

When the piece is at a full cherry red heat, remove the billet and flux. Adequate fluxing is very important when using a coal fire. Coal fires tend to be dirtier and more corrosive to the work, hence, more flux is needed than with a gas forge.

Cover the piece with a smooth coating of flux. The flux should melt, and the surface should look glassy and wet. With the work area fluxed, return the piece to the forge and slowly bring it up to welding heat. Remember to place the piece into the forge on its edge to allow the heat to rise between the layers and not through them. Rotate the piece to ensure even heating.

Now comes the hardest part of pattern welding in a coal fire—knowing when the piece is at a welding temperature. Since you are welding high-carbon steel to a lower-carbon steel, the welding temperature of the high carbon is lower than the mild steel. This means that instead of a light orange/yellow heat, you can weld at an orange heat.

Welding at a lower temperature does several things. First it helps to prevent burning the steel; second, it prevents excessive grain growth; and third, it means less loss of material to oxidation and scale.

When the steel is at the proper heat for welding, the flux will be boiling on the surface. Quickly remove the piece from the fire, place it on the anvil, and strike it lightly yet firmly. You should be able to "feel" the pieces weld; it should act "sticky." If you do not get a weld, immediately reflux lightly, return the piece to the fire, bring the temperature up slowly to a slightly hotter temperature, and try again.

When the first section is welded, proceed as before, overlapping work areas until the entire piece is welded.

As you are working, make certain that the fire remains clean, deep, and clinker free. It takes a considerable amount of good, quality coke to weld even a small billet. Also, keep the air blast to a minimum to prevent excessive oxidation and surface damage to the billet.

The temperature of the fire should remain as constant as possible while the piece is being heated between welds. Any excessive rise in temperature can cause the steel to burn, and any significant drop can cause cold shuts or incomplete welds.

It is easier to maintain a welding heat in a deep, clean fire than in a shallow or dirty one. Do not be afraid to clean the fire during welding sequences, as a clean fire is an utmost priority. If any scale, slag, or clinkers get trapped between layers during the welding, they will show up later as ugly slag inclusions that can ruin the piece.

With the first welding course completed, I strongly suggest that a second weld be performed just to make certain that everything is good and solid. With the welding done, let the bar cool slowly in either a hot box or sand until it can be handled.

Check the bar by grinding the edges and flats of the billet. You should see bright, shiny material, with a slight difference in the sheen indicating the different layers that you welded together. As you become more familiar with the process, you will find it easier to differentiate between the materials.

Also, examine the flat surfaces for signs of burning such as surface crazing (cracking), excessive carbon runs, or oxidation. This way you will be able to see if you are working in the proper temperature range. If the piece is overheated but not totally burned through, it is still salvageable by careful forging and rewelding. This reworking will refine the grain structure down to a usable point, and the rewelding will further refine the process as long as the proper temperature ranges aren't exceeded.

How do you know you are in the proper range? By the simple fact that the piece welded through and didn't burn. It is that simple. Remember that you should always strive to weld at the lowest temperature possible to prevent these and other problems from occurring.

If you have a soundly welded bar, continue drawing the material out and prepare to proceed further with the process.

Pattern Welding in a Gas Forge

This is the easiest way to weld, but a gas fire is limited in that it is hard to get a small, localized heat. But for production quantity work—say, pieces several feet long—a gas forge is king.

The material is prepared basically the same as when welding in a coal forge, except that there is no real need to place the mild steel on the outside of the billet, as there is little chance of overheating the steel in a properly heated and maintained gas forge. I suggest that you start with 1/8-inch-thick 1095/1018 for blade material, as these stick like glue in a gas fire. It is very important that the mill bark (surface scale) be removed prior to assembly. This scale can cause a bit of a problem in a gas fire, but since it is easy to remove, just do it and don't worry about it.

I build my billets with the high carbon on the outside, as I find it easier to weld that way. I usually start out with either seven or nine layers of material in this thickness. While you can use thicker material, I find that the 1/8 inch is good to start out with. As for length, 8 to 12 inches should be sufficient.

Some makers like to weld a small bead (either gas or arc) around the ends of the billet, but I feel, as I have said before, that this is simply intro-

LOW CARBON

HIGH CARBON

Figure 8. Due to the higher degree of control in a gas forge, you can place the high-carbon layers on the outside of the billet without danger of burning the outer layers.

ducing another form of contaminant into the billet. I suggest that you wire the billet together and simply cut off the wire wrapping as in a coal forge.

Your forge should be well heated and up to a welding temperature (approximately 2200 to 2300°F) and with either a neutral or slightly reducing atmosphere. I prefer the reducing atmosphere when I am welding high carbon/mild steel billets because it is less prone to scaling.

With the forge up to heat and the billet prepared, place the billet into the forge edge up to let the heat surround the piece and heat it evenly. As the piece heats, rotate it to allow for a perfect heat, and when it is at an even cherry heat, remove and lightly flux, making certain that it is coated evenly and that the flux is penetrating between the layers. Too much flux can cause severe splatter during the actual weld, and in the worse case it can become trapped between layers, which will result in slag inclusions.

As the temperature rises, the flux will become thinner and thinner in its consistency. It should look like very hot syrup or honey. As the piece approaches welding heat, the flux will start to bubble. *It is now ready to weld.* Remove the piece and quickly strike the billet to start the weld. I work in overlapping sections of approximately 4 to 6 inches in length. The overlapping is important, as this makes certain that the entire piece is welded and that any missed spots are rewelded.

It is of utmost importance that the welds be 100-percent perfect. Cold shuts, slag inclusions, cracks, or any other imperfection will only cause unsightly flaws in the finished blade that will be difficult, if not impossible, to correct.

Remove the wire wrapping as you work your way down the bar. This will help keep the laminate layers in the proper position. It is important that the layers remain straight and even if you are going to pattern the piece later on.

When the piece is welded, go back over it with an additional welding course to make certain that the welds are sound and perfect. Then proceed with drawing and forging the billet to the desired number of layers.

COMMON PROBLEMS

There are numerous problems that can arise during the process of welding. The most common ones are easily prevented, but you should still know what they are, what they look like, and how they can be prevented or dealt with.

Cold Shuts

These are simply areas that are not welded. They appear as fine black lines and are easily corrected by rewelding the affected area. Cold shuts are totally preventable by making certain that you have an even, deep, correct heat.

Cold shuts are caused by attempting to weld at too low a temperature. They can be corrected by rewelding at the proper temperature if they are detected during the welding or forging processes. (Photo by Gary Thompson)

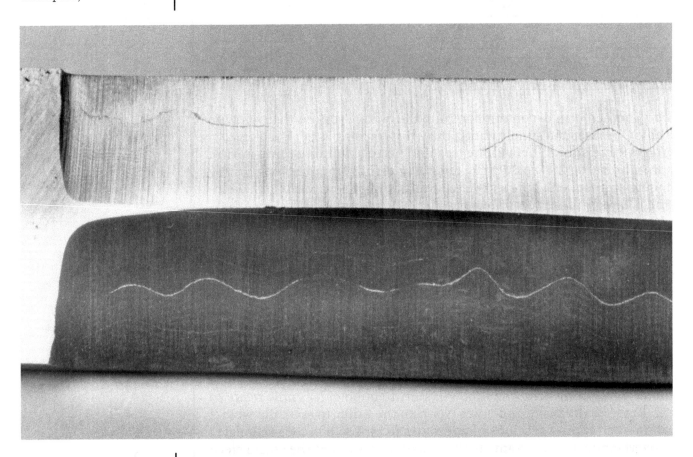

Slag Inclusions

These are pockets of slag, scale, flux, clinkers, ash, or any other foreign material that get trapped between the layers during the welding process. These are often uncorrectable, but they are preventable by keeping the weld surfaces clean and free of foreign materials and by using the proper amount of flux.

Surface Crazing

These appear as small spider-web-type cracks. They are very shallow, but on occasion they can run quite deep into the bar. They are most commonly encountered when using a material with a high nickel content in the billet and are easily ground down if the problem is not too severe.

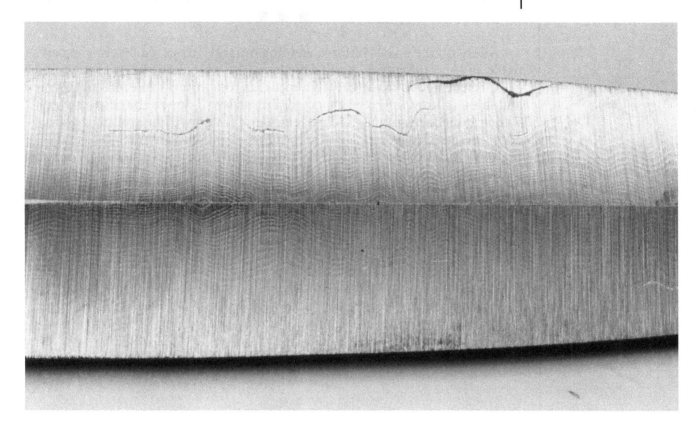

Prevention is simple—make certain that you are not working the material on the cool side, as this will cause surface separations.

Red Short

This is when the steel billet crumbles when struck. This can happen during welding or forging. It is caused by too much heat. All that can be done to correct this is to prevent overheating and to cut off the affected area and try again.

Weld Shear

This is usually encountered when twisting a bar and is the result of one or more factors. The first is material incompatibility. If the materials welded are too dissimilar in working characteristics, the weld area may simply come apart. The second is incorrect temperature, either too cool or too hot, depending upon the materials used. Here, experience will tell. If you are careful, chances are that weld shears can be rewelded without any negative effects to the pattern.

Delamination

This is similar to weld shearing, but is far more severe, as the entire piece could start to come apart. This is caused mostly by working at too low a temperature. You should be able to reweld the billet if you catch the problem before it is too far along. Work at a higher heat to prevent this from happening.

A slag inclusion is caused by a foreign substance becoming trapped between layers, preventing a weld. To prevent this from occurring, make certain that the weld surfaces are clean. (Photo by Gary Thompson)

■ ■ ■

All in all, the basics of forge welding must be mastered before you can make any sort of pattern-welded blade, as the weld is the heart of the process. To the neophyte, it can all appear far too difficult to even consider, and some failures are to be expected. But this will not be the case forever. The first piece that you weld perfectly and finish will be well worth the effort. Practice is the key, and there is no reason why anyone who is willing to invest the time and effort into learning to weld cannot make a beautiful pattern-welded blade.

Basic Patterns for Pattern-Welded Steel

With the forge weld conquered, you are now ready to start the most basic pattern-welding techniques. These patterns are the building blocks of the more advanced composite patterns that you will be reading about in the next chapter.

A word of advice: before you rush out and start to do more advanced designs, I strongly suggest that you work to master not only the forge weld but the straight lamination pattern. Some makers refer to this type of pattern as a "random" pattern. To me, this means that they simply do not care enough to give any more thought to what they are doing other than simply welding the steel. While this school of thought is suggested for the novice, after a few successful blades, one should start to strive for dead straight laminates. It is the straight laminate material that will give the best patterns later on. You will see that I refer to this numerous times in this volume.

A straight laminate pattern is a mark of a careful and successful craftsman. Take the time to work the steel slowly and pay attention to detail and you should be doing this in a very short time. Once mastered, it will help in the patterns that follow.

THE STRAIGHT LAMINATE PATTERN

The straight laminate pattern is, in theory and in terms of construction, the simplest pattern, yet it is still one of the most difficult for the bladesmith to master. The beginning of all other patterns, it is simply alternating layers of material, with the layers running lengthwise along the blade.

The materials can be most anything. I have had excellent results with the high-nickel alloys as well as pure nickel. The layer count is very important, as there is no manipulation of laminates to enhance cutting ability, so the count should be no fewer than 350 layers (unless pure nickel is used, and then it should be no higher than 200 to 250 layers).

A straight laminate pattern is made by the welding/cutting/stack-mg/welding process until the desired number of layers are reached. To

figure out the number of layers in a piece, simply take the number of layers you started with and multiply these by the number of pieces you cut the bar into prior to the last weld, as such:

# Layers	Cut Pieces	# Layers:
5 (welded)	3	15 (first weld)
15 (welded)	3	45 (second weld)
45 (welded)	3	135 (third weld) *
135 (welded)	3	405 (fourth weld)
405 (welded)	3	1,215 (fifth weld)

*After repeated welding/forging, you will start to lose layer count due to surface scale and material reduction. For a more accurate estimation of layer content, deduct 7 to 10 percent from the total for each weld after the third weld.

Since the layer count is more or less a geometric progression, it doesn't take very long to get it up to an acceptable level, but watch what happens when you go to eight layers with the same number of cuts and welds:

# Layers	Cut Pieces	#Layers:
8 (welded)	3	24 (first weld)
24 (welded)	3	72 (second weld)
72 (welded)	3	216 (third weld)
216 (welded)	3	648 (fourth weld)
648 (welded)	3	1,944 (fifth weld)

As you can see, in theory there is a big difference in the number of layers between a billet of five layers and one of eight, with the same amount of work. This should be taken into account when you are starting, as the human eye is not able to make out a pattern above 900 to 1,000 layers in a 3/16-inch-thick blade, since each layer is only 0.0001 inch in thickness (here again, I am speaking in mathematic theory).

When welding and working this pattern, work alternate sides of the billet evenly in order to keep the laminations straight and running true. Be very careful if you are using a power hammer to draw the piece out, as the immense amount of pressure and force can easily distort the layers. Make certain to alternate the flats as you work or else you will have an uneven patterning on the finished piece.

When you have reached the desired number of layers, go ahead and forge the blade, grind, and finish as desired.

This straight laminate pattern is the starting point for all other patterns. Be they twisted, surface manipulated, material manipulated, or composite, they all start out as a straight laminate.

With the straight laminate mastered, you are ready to proceed to the controlled patterns of pattern welding.

The ability to weld and forge dead straight laminates is an absolute requirement for any patterning that may be desired. This straight laminate pattern was made by the author. Materials: A203D/E, 1095/M-2. (Photo by Gary Thompson)

BASIC PATTERNS

There are several different types of patterns that can be made, and these types are broken down into three different classes: surface manipulation, material manipulation, and the most complex, composite patterns. The "easiest" of the three is surface manipulation.

Surface Manipulation Patterns

These patterns are more or less what the name says: a surface treatment. The patterns are put into the bar after the billet has been forged and prior to the blade being formed. The patterns tend to be shallow and can be overground, which can in effect "erase" the surface pattern. But when done properly, surface manipulation patterns can be very beautiful.

The Ladder Pattern

This pattern is perhaps the best known of all pattern-welded steel. While it is the most popular, many smiths do not take the time to do it as well as it can be done. It is not a very difficult pattern to execute properly, and all that is involved is careful spacing and control.

To make a ladder pattern blade, weld up a straight laminate billet of at least 200 layers and lay out the pattern. You will be cutting grooves into the billet, so make certain that it is at least 25 percent thicker than the finished thickness desired.

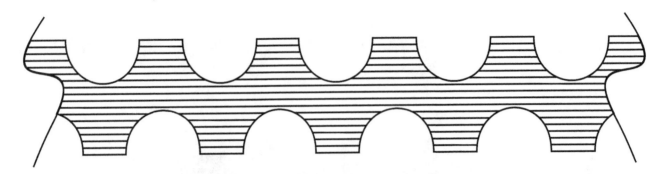

Figure 9. Place the grooves for ladder patterning so that they alternate as shown, not so they align.

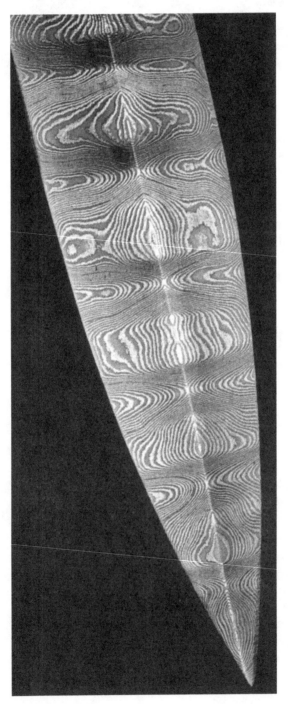

A double-edged ladder pattern made by the author. Materials are meteoric iron and 1095 high-carbon steel. (Photo by Gary Thompson)

While you are doing the layout, make certain that the grooves do not line up on both sides of the bar. You want to stagger the grooves, as shown in Figure 9.

The spacing is very important. The closer the grooves are to each other the tighter the pattern will be. I have had excellent results with spacing as close as 1/8 inch using 3/16-inch-wide grooves to as far as 3/4 inch using 1/4- inch-wide grooves. (These are edge of groove to edge of groove measurements.)

The closer grooves are more difficult for those starting out, so I suggest that you try spacing the grooves 1/2 inch apart using 1/4-inch-wide grooves.

Groove depth is also a matter of importance. I usually cut them approximately one-third of the bar depth, so if the bar is 3/8-inch thick, I cut down 1/8 inch on each side. Since the grooves are staggered, this works out quite well. You can cut deeper if you wish; doing so will give you a denser pattern. Just remember that control of the width and depth of the grooves is very important. You want to be as consistent as possible.

Use a round file or a grinder to cut the grooves. I suggest that you go with the file or a mill with a ball end cutter if you have one available. This is more precise than doing it by hand, but a good, even pattern can be hand-cut using either the file or grinder methods. Just be careful, and do not rush the cutting.

With the grooves cut, you are ready to forge the billet into the finished bar. I suggest that you do this flattening at a welding heat just to make certain that all the laminations are welded. If by chance there are any cold shuts or inclusions, once you start to grind you can have a section simply flake off the blade. This is rather annoying to say the least. The billet will stretch a bit due to this flattening, and the edges will appear a bit rippled due to the undulation of the grooves/laminations. Simply smooth these out with the hammer, lightly forging on the edges.

The ladder pattern can be one of the most attractive of the simpler patterns. It is best suited for a symmetrical, double-edged blade, although it can be used for a single-edged blade with a little more planning and more careful forging to shape.

Hugs and Kisses

This is a pattern that I developed from a variation of the ladder pattern. It can be difficult to master, as both hammer control and the cutting of the ladder rungs need to be as precise and uniform as possible.

You need three sections of straight laminate of at least 60 layers and two pieces of unlaminated high-carbon steel (1095 or similar) the same length and width but no thicker than half the thickness of the laminate. I suggest that the laminate be approximately 3/16-inch thick and the high carbon 3/32 inch at the thickest, with 1/16 inch being almost ideal.

You will make a billet with the laminate and high carbon as shown in Figure 10. This way when you weld the billet you will have a layer of laminate, high carbon, laminate, high carbon, and laminate.

Weld the billet, paying close attention to the way you are working. You do not want to overwork either side. This way you will not deform the laminate and carbon layers. You want to keep them as even as possible or else this will not work very well.

When you have the billet welded, forge down to the desired size for a ladder-pattern blade, here again making certain that the laminate and carbon layers are not deformed or forced out of alignment.

Figure 10. Material positioning for hugs and kisses pattern prior to welding.

LAMINATE

HIGH CARBON

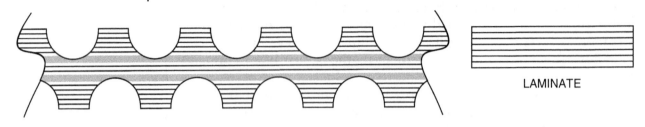

LAMINATE

HIGH CARBON

Figure 11. Cut the grooves for hugs and kisses along the same lines as for the ladder pattern. Groove depth must be approximately halfway into the high-carbon layer.

The hugs and kisses pattern developed by the author. The X's and O's are very pronounced. Materials used are 1095 and pure nickel. (Photo by Gary Thompson)

Now mark and prepare to cut your grooves.

When you are cutting the ladder grooves, you will need to cut no deeper than to the first high-carbon layer on each side. If you cut any deeper you will not get the desired X pattern. Also, remember to alternate your grooves from side to side.

With the rungs cut, you will now need to cut another groove lengthwise down the center of the bar on each side. This groove should be no deeper than half the depth of the sideways rungs. This lengthwise groove makes the pattern more pronounced in the finished blade, especially if the blade is fullered.

Forge the billet flat, again doing this at a welding heat. You will experience the same ripple effect as with a standard ladder pattern. Finish forging to shape and complete.

As with the ladder pattern, the hugs and kisses pattern is well suited for a symmetrical, double-edged blade. I have used this pattern in a double-fullered Dirk blade (as seen in the photo) with great success. This pattern really needs to be fullered in order to bring out the best results.

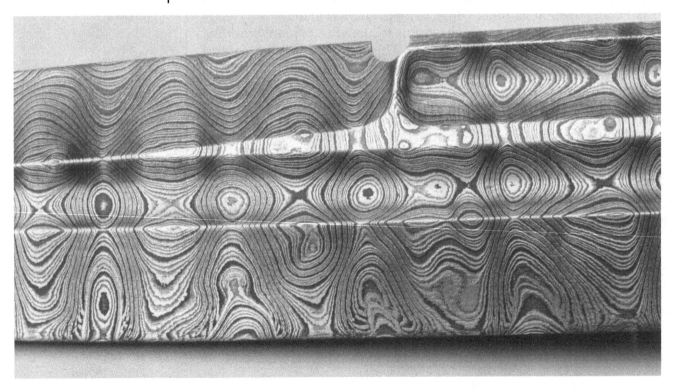

Butterfly Pattern

This is another variation on the ladder pattern. As in the ladder, grooves are cut into the billet, and the billet is flattened prior to final forging to shape. But instead of cutting grooves parallel, you cut them so they form a series of X's along the length of the blade, as shown in Figure 12.

Here again, while it is almost impossible to prevent the cuts from overlapping on opposite sides, cut the pattern so the center of the X's are offset. This will help prevent glitches that can result in the pattern looking a bit "off."

Figure 12. When cutting the X grooves for the butterfly pattern, make certain that groove depth is uniform and that the centers of the X's are alternated from side to side of the billet.

Try to cut the grooves in the X's as even and identical in both angle and depth as possible. Uniformity is very important. You can either cut them in with a file, a grinder, or a mill. The more care you take, the better this pattern will turn out.

With the grooves cut, forge flat and then shape into a blade.

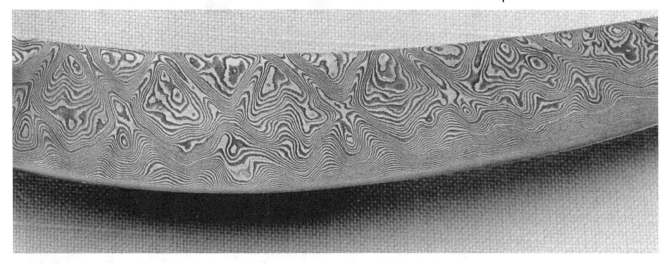

A butterfly pattern made by Wally Hayes. Materials are high-carbon and low-carbon steels. (Photo by Jim Weyer)

Quilt Pattern

This is a rather complex version of the butterfly pattern. The only difference is that instead of a single row of X's, two or more rows of narrower and smaller X's are cut, as shown in Figure 13.

Here again, layout is important; the cross of the X should be offset from each side of the blade. This is a rather tedious pattern to try to cut by hand, so I suggest that these grooves be cut with an end mill.

With the grooves cut, proceed to flatten and finish. It can be a very beautiful pattern.

Figure 13. When cutting the quilt grooves, layout is very important. Here again, make certain that the centers of the X's do not align on opposite sides of the blade.

Pool and Eye/Wood Grain

This pattern is seldom seen nowadays. Why, I simply do not know. It involves the drilling of small holes in the laminate prior to the last two welds.

Laminate the billet until you are two welds short of finished. Make certain that the pieces are annealed prior to drilling.

Next, lay out holes of various diameters. I use 3/32, 1/8, 3/16, or 1/4 inch. Drill these holes on one side of each piece to a depth of approximately a quarter of the thickness of each bar. You can space these randomly or lay them out in an exact pattern, although this pattern is supposed to look rather "organic" so a more random spacing is desirable.

With the holes drilled, flatten the surface of each bar and then weld together. It really doesn't matter if the drilled surfaces touch or not at this point. Weld, draw out, and cut into two pieces prior to the last weld.

Figure 14. When drilling the holes for the pool and eye pattern, you can use various drill diameters and depths to give the pattern a more random look.

You now need to lay out and drill another series of holes, this time to a depth of approximately a quarter the thickness of the billet, here again on one side of the billet only. Flatten and weld the drilled surfaces together. This way when the blade is forged to shape, the drilled holes, which form little bull's-eye patterns, will be stretched and deformed

The pool and eye pattern is a more or less "random" design that can be very appealing with its almost wood grain appearance. The blade is by Bob Brothers. Materials are 1095 and 1018. (Photo by C. Wells)

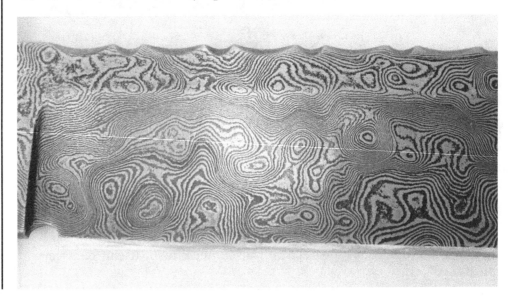

into nice ovals and other shapes by the forging, giving the nice "knot" pattern in the blade.

This pattern is usable for almost any style of blade: single- or double-edged, symmetrical or asymmetrical.

Frog Skin/Pigeon Eye

This is a variation of the wood grain pattern, but the holes are drilled after the last weld is completed and prior to final forging into a blade. All drawing out must be done before the holes are placed in the billet or else the pattern will be deformed.

Drill an evenly spaced pattern of holes of no larger than 3/16 inch in diameter and to a depth no greater than one-third the billet thickness. The billet can be to finished length and slightly under finished width; as for thickness, it should be approximately 50-percent thicker than the intended finished blade.

It is permissible to align the drilled holes, but I feel that a better pattern evolves if the holes are offset from side to side, as seen in Figure 15.

Flatten the billet and forge to finished thickness.

This rather bizarre pattern is seldom seen. It is suited to most any blade style, but it can be easily erased by overgrinding.

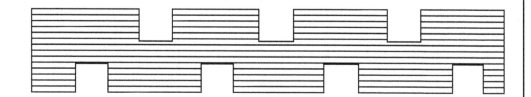

Figure 15. To give the wood grain effect, drill holes in an offset arrangement.

MATERIAL MANIPULATION

In addition to the above methods of patterning, there is another pattern-inducing procedure known as material manipulation. This is where you work the entire billet, not just the surface. This translates into a pattern that runs throughout the billet, not just on the top of the layers. There is little if any worry about grinding your way through the pattern and erasing it.

Most of these patterns involve twisting the billet in one manner or another, so you should already have some sort of twisting tool, as described in Chapter 1, along with a sturdy vise and wire brush.

Basic Twisting

This is perhaps the most stressful process that you can subject a welded billet to. It can cause weld shearing, cracking, and delamination. You must be able to make 100-percent perfect welds before trying to twist a billet.

The square bar is twisted tightly prior to flattening and forging into a blade. (Photo by Gary Thompson)

Most billets will either be square or round. For the simpler patterns, I suggest that the billet be rounded, while for the more elaborate patterns it should be square, with chamfered (broken) corners to prevent cracking during the twist.

The keys to successful twisting are temperature control and attention to what is going on. An even twist is not very hard to do, but you'd be surprised at how many smiths cannot do it.

The basics for twisting round or square stock are the same, with the square requiring a bit more care so not to allow cracking.

Twisting a round rod is fairly easy. Take an even, light cherry heat on the entire length of the bar (on longer bars you can work in sections), place it in the vise, and, using the twisting wrench (or whatever you have for this purpose), start to twist the bar. Some makers like to twist with the workpiece horizontal, but I prefer to do this with it held vertically.

As you are twisting, some scale will fall off. To help remove this scale, simply wire brush it off. You will notice that the center of the rod twists faster and tighter than either end. To correct this, take a purchase on the center of the bar with the wrench and even out the twist. You may need an additional heat or two to do this evenly. If need be, reverse the rod in the vise and/or move the rod in the vise. This process is pretty much self-explanatory.

At times it can be very difficult to tell just how much you are twisting a round bar, but with practice you will be able to see the twists on the bar surface.

When you first start out I suggest that all twisting be done at a welding heat, since this will reduce the chances of weld shears or delaminations.

Twisting a square bar is basically the same as using rod stock, except that it is easier to see the twists and maintain an even rate of twist. Again, work at a higher heat than normal. Also, the edges of the bar need to be chamfered slightly to help prevent cracking and crazing. You

will also note that the sides of the billet will start to take on a fluted appearance from the twisting action. This fluting is where the cracking will start, so keep a watchful eye for this.

If you need to, take a purchase on the center of the bar to even the twist and/or move the work in or out of the vise. Do not worry about marring the flutes due to either the vise or the wrench jaws. These marks will not be visible on the finished blade.

If you are planning on matching bars for a given pattern, work the bars one at a time. Trying to alternate them can become confusing. This is especially true when you are doing a multiple-bar, alternate-interrupted twist pattern.

As you are twisting, scaling will be very heavy, so wire brush frequently. As the piece starts to cool, twisting will become more difficult and harder to control over the length of the piece. Take additional heats if required to finish the piece.

How much to twist?

This is a good question. I suggest that you twist at least 15 percent tighter than you feel is necessary for any given pattern. Remember that some straightening of the pattern will occur due to subsequent forging and working.

Some patterns require a very tight and even twist, while a slower, more open twist is needed with others. Another thing to keep in mind is the smaller the diameter, the easier it is to get a tighter, more even twist. Also, the easier it is to shear off, crack, or otherwise ruin it. Once again, practice and knowledge of your materials are important.

Some materials are very forgiving when it comes to this sort of thing. 1060/84/95, 1018, A203D/E, and wrought iron are all easy to twist and make a great blade in combination. Therefore, I suggest that you start out using these and then work your way up to the more difficult materials.

Pure nickel sheet is perhaps the most difficult material to get to twist without problems. It does give the best contrast, but it can be downright contrary when it comes to twisting. Weld shearing is very common with this material, so work it at a welding heat. It is also prone to cracking, especially on the edges of square bars. If you can, use a round cross section when you are using pure nickel sheet for a twist pattern. This will lessen the chances of corner cracks.

With the basics of twisting understood, you are ready to move further into the material manipulation patterns.

Maiden's Hair

This is a classic pattern and one of the most taken-for-granted ones that every smith is "expected" to know how to make. It can be quite beautiful in its simplicity and can be used for any blade design.

To make this pattern, weld up a billet of at least 200 layers and forge into a round cross section. As for the diameter of the rod, this will depend on the desired finished size. Remember that the larger the diameter, the harder it will be to twist and the smaller the amount of twist.

I usually use 3/4-inch-diameter round for this pattern, as this easily forges into 1 1/4- to 1 1/2-inch-wide billets. Smaller or larger rods can be

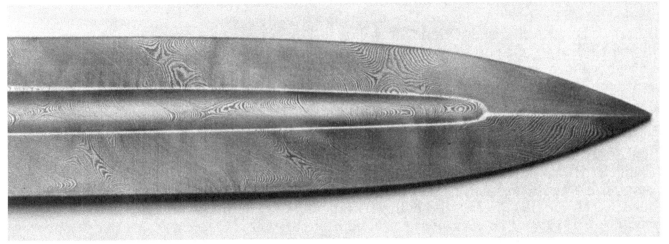

A maiden's hair pattern made by the author. This is another more commonly seen design. The patterning can be bold or subtle, depending upon the materials used and the amount of layering. Materials are 1095 and meteoric iron. (Photo by Gary Thompson)

used for this pattern, and it is best to experiment with different sized rods to see what diameters work best for your particular methods, as everyone works differently.

The amount of twist is another matter entirely. This pattern is not a tightly twisted one. Rather, it is characterized by a smoothly flowing pattern of diagonal lines. This translates into a rather "slow" twist of no more than, say, one complete twist per every inch of billet length.

Twist the billet either clockwise or counterclockwise. I have had nice results in using a variable rate of twist, with some places twisted a bit tighter than others. This lends itself to a bit of variety in the pattern.

With the rod twisted, flatten into a billet and forge into a blade.

Star Twist

This is a variation of the maiden's hair. In fact, it is the same basic pattern but with an extremely tight and even twist.

Using the same basic billet but square in section, twist the bar as tightly as possible, maintaining an even twist rate. Direction doesn't matter as long as it is as tight and even as you can get.

The reason you use a square billet is that you want the "stars" to be fully formed. Twist at a welding heat. Be careful not to cause any cracking. Also, be very careful not to overtwist and shear off the bar.

With the bar twisted, forge flat, again at a full welding heat to weld any shears or delaminations. This way you will prevent any difficulties later.

The star twist is tighter than a maiden's hair and is suited for most any blade shape or style.

Whirlpool

This pattern is another variation of the basic twist pattern. As in the star twist, a tight, even twist is required. Twist as in the star twist pattern and flatten. Do not flatten completely because you still need a good deal of unfinished thickness.

With the billet flattened out but still on the thick side, lay out grooves as in a ladder pattern blade, making certain that they are offset from either side. Cut the grooves exactly like a ladder pattern but to half

the depth of the billet thickness and as even as possible. When forged flat, these grooves will bring the twisted laminates to the surface, causing a very pleasing swirl effect.

Flatten and forge into a blade.

This pattern can be used for most blade designs.

■ ■ ■

These are only a few of the numerous patterns that are possible. Experimentation is the only way to develop them, and new ones can be "discovered" by most anyone who is interested in spending some time to figure them out.

BLADE SHAPE AND GRIND
AND THEIR EFFECTS ON THE PATTERN

There are some patterns that are better suited for some blade styles than others. A symmetrical, double-edged blade will show any pattern off at its best. It is very difficult to get a good effect with some patterns (like a ladder pattern) on a single-edged blade. To get the best results, more precise forging and a great deal more forging to shape are required.

When forged into a single-edged blade, the ladder pattern displays a wavelike pattern along the cutting edge. The blade is by the author. Materials: 1095 and A203D/E. (Photo by Gary Thompson)

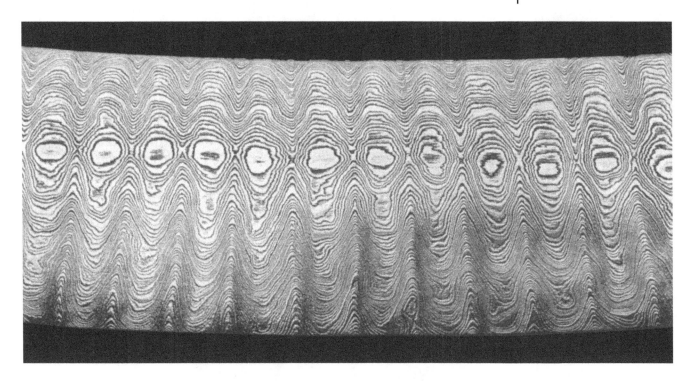

Then there are patterns that can be used with almost any style or grind of blade. These are, more often than not, the twisted patterns like maiden's hair, star twist, whirlpool, and others. Even then, these can be different on a single-edged and a double-edged blade.

The straight laminate types of pattern such as a ladder are best suited for double-edged styles of blade due to their makeup and how the

Figure 16. On a single-edged blade, a ladder pattern will appear as a series of wavy lines.

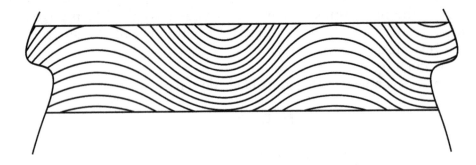

pattern is exposed on the edge grinds. While this is hard to explain, it is easier to illustrate in a line drawing (fig. 16). As you can see, only half of

Figure 17. On a double-edged blade, the ladder will form "rungs" on either side of the grind line.

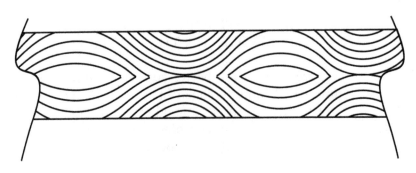

the rungs are visible on a single-edged design. This is due to the fact that only one bevel was cut, revealing only one side of the pattern.

A double-edged pattern will result in a pattern like that shown in Figure 17. Here you have the classic ladder pattern of rungs running across the width of the blade. This is due to two bevels being cut into the blade, revealing both sides of the pattern.

A twisted pattern such as a star twist will remain pretty much the same whether it is a single- or double-edged design. As you can see, the patterns in the photo are, for the most part, the same. In fact, these two pieces were forged from the same bar of steel. So as you can see, some patterns are more "universal" while others need a specific design to be at their best.

Other factors that can affect the pattern are the type of grind (whether it is a flat or hollow) and the amount of forging to shape you do prior to grinding.

All other things remaining equal, the

A star twist will have two different patterns in a single- or a double-edged blade, as shown here. Both blades were forged from the same bar by the author. Materials are 1095 and pure nickel. (Photo by Dan Fitzgerald)

more you forge to shape, the less material will be removed in the grinding operations. This means that there will be fewer laminations cut, therefore revealing less of a pattern.

Also, since the steel is in fact compressed, this translates into a finer laminate pattern toward the edge. (It is this finer pattern that makes forged-to-shape pattern-welded steel better cutting than that which is simply ground out of a commercially available pattern-welded bar stock.) This is more readily seen with a flat-ground blade than on a hollow-ground one by the fact that the flat grind cuts across at a uniform angle to the central plane of the blade, as shown in Figure 18.

As you can see in Figure 18, the flat grind cuts across the laminates at a more or less even angle. This means that each layer is cut the same amount in any given area of the blade, resulting in a pattern that looks like each lamination is the same thickness.

On a hollow ground blade, the curve of the grind, since it is done on a radius, will appear as wider layers toward the edge, as seen in Figure 19. This will cause the effect of a somewhat coarser pattern toward the bottom of the grind (toward the edge) due to the fact that more of the surface of the laminations are visible than the edges.

Another factor affecting the pattern will be blade cross section. If you are fullering the blade, the fullering process will cause a compression of the laminates, here again causing the pattern to be finer in the fuller than along the edges. This should be taken into consideration when you are forging the blade.

The opposite of this effect occurs when the blade is forged with a center rib. Here the edge area laminations are compressed to a higher degree than the center rib. The rib will appear to be made of a coarser laminate, while the edges will be more refined in terms of layer count.

*Figure 18.
On a flat-ground blade, the laminates are exposed in a more or less even angle and will appear to be of the same thickness.*

*Figure 19.
Hollow grinding will cause the laminations to look wider as the grind approaches the edge due to the arc of the grind.*

Figure 20. When properly forged, a fuller will compress the laminates, causing them to appear thinner once the fuller is ground and polished/ etched. This effect is similar to edge packing

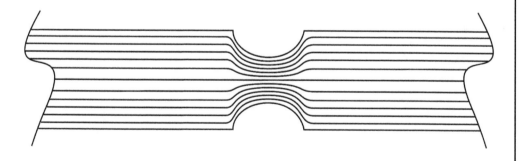

■ ■ ■

As you can see, there are many things that can affect the patterning of a blade. These are the more common ones. Remember that every time you shape, bend, flatten, fuller, or do anything else to a blade, you are not only changing the shape, you are also changing the pattern. This change can range from the ever so subtle to the dramatic.

That is the beauty of using this material—the uniqueness and individuality of a pattern-welded blade. Careful workmanship and close attention to detail will always be the best way for any craftsman who takes his or her work seriously.

The Composite Patterns

These patterns are perhaps the most difficult and complex patterns that can be made. Even the "simpler" ones use at least two separate pieces of laminate to make a billet, while the more complex use upwards of eight or more laminated pieces to fashion a single bar of a given pattern.

The patterns described in this chapter are known by many different names, some of which may not be given in their description. But they are beautiful no matter what name they are called, and all are within the reach of most smiths' abilities.

The manufacturing of these patterns relies strongly upon the ability to make 100-percent perfect welds, welds without any cold shuts, slag inclusions, crazing, weld shearing, or any other imperfections that can cause the patterns to be marred or destroyed.

It is not unusual to take considerable time to make up the billet for some of these patterns, especially the more complex ribbon patterns such as the traditional Turkish or some of the medieval European patterns. Forty to one hundred hours of working time is not out of the question, especially with sword-length pieces.

Regardless of the pattern you are trying to duplicate, the first step is welding a sound billet and making certain that the laminates are running as straight and true as possible down the length of the bar. This means careful forging, taking care that the billets remain as squared as possible during the welding and forging of the individual bars.

MATERIALS

Some materials are better for these complex patterns, while others, such as pure nickel, are simply too difficult to weld into composites for most smiths until they have some experience in both working this material and making the patterns.

I have had excellent results with welding A 203 D/E with 1095, as well as the more traditional 1010/18 to 1095. Either of these combinations works beautifully, and there is enough carbon difference to result in a decent degree of patterning, although the A 203 D/E and 1095 will give the most vibrant patterns.

Pure nickel sheet can be used instead of the A 203 D/E but, as mentioned, there are some difficulties, as the nickel tends to be rather difficult to twist tightly due to the fact that it is prone to weld shearing. It can be used when worked slowly and carefully. It does make the most vibrant watering of any of the laminations, but it requires experience in using this material in flat laminate patterns before a composite twist pattern can be attempted.

With the materials chosen and prepared properly, you must still decide on what pattern you wish to make.

The basis of most composite patterns are twisted sections. These twists can be uniform, interrupted, graduated, or any other combination you can think of. Some of these patterns are addictive in that each pattern you make and develop opens another variation that you can't wait to try out. Believe me, I know.

MATERIAL PREPARATIONS: THE BASIC BILLETS

The composite patterns use two or more pieces of laminated materials. If these pieces are to be uniform with either one or more other pieces, I suggest that you weld a larger piece of flat laminate and cut the smaller rods from this larger piece. I have found that this not only saves time and material, it also results in the individual rods being as identical to each other as possible.

Using my equipment (I have a rather well-equipped studio), I can easily weld and work billets that are 1 1/2 to 1 3/4-inch-square and up to 24 inches in length. These billets give me more than enough material to work into complex composite patterns in sword-length pieces. If you have the knowledge and skill with working larger pieces, which by now you should, I suggest that you try it, starting out on the "small" size of 1 1/4-inch-square by 16 inches long and working your way up to the larger, more difficult-to-work bars.

To cut these pieces, you can either hot chisel them (though this makes for additional work in truing the rods square again, as the chisel never cuts a square edge), or fully anneal the bar and cut it using a metal-cutting band saw with a bimetal blade. I use the band saw. By doing it this way, I can weld, cut, twist, and square enough material for a composite sword core in less than six hours. It does save a great deal of time.

TWO-PIECE COMPOSITE PATTERNS

The simplest composite patterns are made from two pieces. These pieces can be twisted, flat laminate, or any combination of the two. Some of the more common patterns are described below.

Chevron Twist

This is a very basic pattern that can be quite elegant when done properly. It is simply two twisted bars of straight laminate of no fewer than 100 layers each.

Weld the billets until the desired number of layers is reached and forge the bars to 1/2-inch square. Slightly grind the corners round to prevent cracking.

Twist the bars tightly, one clockwise and the other counterclockwise. It is the opposite twisting that gives the chevron pattern. I suggest that you twist as tightly as possible to achieve the best pattern (as with all other twisted patterns, they will tend to straighten out as they are forged into a blade). Care must be taken that you do not twist the bar in two. There is no way to tell how much twisting a given bar will withstand, so experience is very important.

With the bars twisted, forge them square into a rectangle. Make certain that the pieces are as close to being the same dimensions in width and thickness as possible. Length is not as critical, as the longer piece is easily trimmed, but the width and thickness cannot be trimmed without fouling up the pattern. You should work at a welding heat when forging these pieces, because by doing so, you will be welding any shears, cracks, or delaminations that may have occurred during twisting.

With the pieces forged to shape, you will next need to clean the surfaces that are going to be welded together. Weld them edgewise on the narrow dimension so you will have a billet twice as wide as an individual bar.

Wire the bars together, with bindings every 3 to 4 inches to keep them in position. Now weld them together, making certain that you do not distort the bars as you are working. Remove the bindings as the weld progresses. Remember to work not only the edges of the bar but the flat as well. This way you will keep the two pieces in proper position, and this will make for a better billet and a prettier blade.

Work your way down the bar, welding and working, removing the bindings until the billet is welded. Take another heat and wire brush off

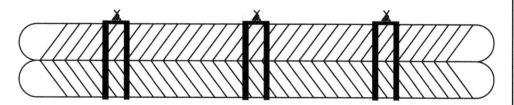

Figure 21. Bind the cores securely with heavy wire to ensure that the pieces do not shift while welding.

any flux, slag, or any other foreign matter that may be stuck to the surface. You should be able to see a slight pattern on the billet surface. You are now ready to work the steel into a blade.

Double Star Twist

This pattern is simply the chevron twist, but with both pieces twisted in the same direction. This makes for star- or cross-shaped patterns in the billet.

Work this pattern the same as the chevron. Both the chevron and star twists are well-suited for symmetrical double-edged blades, as this allows for a uniform pattern to be revealed.

MULTIBAR COMPOSITE PATTERNS

These patterns can get very complicated and take a great deal of time, especially when one starts to do interrupted, continuous patterning like in some of the traditional Viking patterns. While they are time-consum-

ing to make, they result in perhaps the most beautiful of blades, especially in a double-edged blade.

Turkish or Persian Ribbon

This pattern goes by many names, but no matter what it is called, it can make a very beautiful blade. It does take some time, and the amount of material can be amazing, but the beauty is well worth it.

You will need at least four pieces of 3/8-inch-square laminate of no fewer than 75 layers. Twist each piece in a uniform twist as tightly as possible, with every other piece twisted in the opposite direction (i.e., one piece twisted clockwise, another counterclockwise, etc.). Here again, round the corners to prevent cracking. With the pieces twisted, forge into square stock and grind the surfaces that are to be welded clean.

To arrange the pattern, place the bars as follows: clockwise, counterclockwise, clockwise, counterclockwise, as illustrated in Figure 22.

It is very important that the surfaces meet as exactly as possible and

Figure 22. On the Persian or Turkish style of blades, alternate clockwise and counterclockwise cores prior to welding.

that the bars are the same diameter. Length is not as critical as width. In order for this pattern to work properly, the bars must be uniform not only in twist rates but in size as well.

Wire the bars in position and start to weld at one end.

When welding, it is important that all the bars reach the proper temperature in order for the billet to weld. Also, keep in mind that the bar positioning must not change, as this will affect the pattern. Keep the bars in proper alignment during the weld process by working the flat of the bar as well as the edge.

An eight-strand Persian twist blade made from W-1 and A 203D/E by Bill Fiorini. This pattern, while still uncommon, is becoming more popular among today's makers. (Photo by David Scadlock)

Weld your way down the length of the bar, making certain that you are at a welding heat on all pieces involved. This can be very intense to do with more than five bars, but it can be done with as many as eight to ten pieces.

If you are welding more than four or six individual bars, you must not strike any heavier than necessary to weld. If you do, you can easily fold the

bars over sideways and ruin the piece. Remember to keep the bars in their proper position at all times and work the flat area of the bar that was just welded. If any welds open up, reweld immediately.

After the welds are complete, I strongly urge that another welding course be taken just to make certain that everything welded properly.

Gordian's Knot

This is a rather interesting pattern involving four pieces of laminate in the form of squared rods. It can be quite a beautiful blade as long as the laminates are not too fine.

I suggest that the rods be of no more than 100 layers each. Forge these rods approximately 1/2-inch square and tightly twist two rods clockwise and the other two counterclockwise. It is very important that these rods be twisted as tightly and evenly as possible.

With the rods twisted, forge them square again, making certain that you keep track of which rods are which. When the rods are squared, straighten and then grind clean all surfaces before you arrange them into the pattern.

To arrange the rods, place one clockwise rod next to one counterclockwise rod, as shown in Figure 23, doing this with each of the rods. As you can see, each rod touches a rod that is twisted in an opposite direction from the one next to it. This placement is very important in order for this pattern to work properly.

Wire tightly together and weld.

END VIEW

SIDE VIEW

Figure 23. On the Gordian's knot pattern, position two clockwise and counterclockwise billets as shown and weld.

After the first weld is completed, twist the resulting rod in a tight twist. The direction of the twist is not important; just make certain that it is tight and even. Twist at a welding heat to help prevent weld shearing.

When finished with the twist, flatten into the finished billet and start to forge to shape.

Letters and Numbers

There has been a lot of interest in this family of patterns over the last few years, and while they can be tricky to weld up, they really are not that hard to figure out. The figures themselves are made from either square or rectangular mild steel and the fill is high-carbon/tool steel. The whole is surrounded by tool steel plates that hold the assembly together.

Each letter or number is welded individually, forged down, and then welded in sequence to the other numbers/letter. Figure 24 shows how an individual character is welded. As you can see, the letter C is formed from pieces of mild steel, three rectangles and two square. The fill is high carbon, as are the outside plates.

Figure 24. Assembly of the letter C.

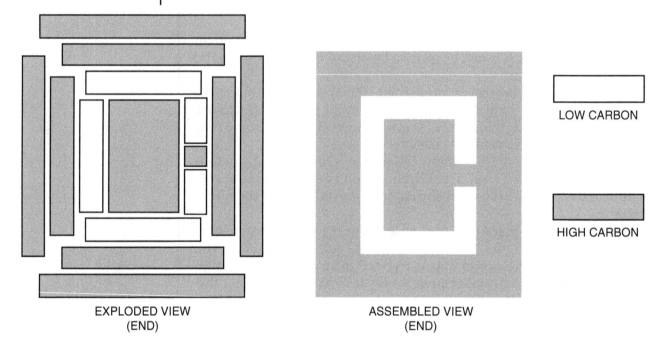

EXPLODED VIEW
(END)

ASSEMBLED VIEW
(END)

LOW CARBON

HIGH CARBON

The easiest way to figure out how to lay out the pieces is with graph paper. This way you can simply "fill in the squares" and then use the sizes and shapes shown on the graph. By using graph paper, you can make any letter or number and most other block-style designs.

You will need to wire the piece together securely to make certain that there is no slippage while working. Another important factor is keeping all welding and drawing operations as even as possible, working from all four sides to minimize distortion and to keep the letter centered in the bar.

When you have the bar welded, draw it out to approximately 5/16- to 3/8-inch square and then weld the next letter/number and do the same. When all the letters are welded and drawn out, position them as required and weld these together, again making certain that you work the piece as evenly as possible to prevent distortion.

With the piece welded, you should either weld it to a piece of straight laminate and twist or draw it out for twisting without the additional laminate. This twisting is very important since it is this that allows for the interior of the billet to be seen and the pattern to be exposed properly. As long as the pattern crosses the axis of the blade, it will be exposed enough by grinding to be seen.

Some of these patterns can take an almost unimaginable amount of time to weld and work, but they can be very appealing to the eye and be the center of many conversations.

Mosaics

This family of patterns is a variation of making letters and numbers. The mosaic family is only limited by your imagination as to what can be welded into a blade. Most of these patterns involve the welding and then "slicing off" of sections and then welding these edge to edge to achieve a pattern. This process is basically the same as letter/number welding.

The simplest pattern is the checkerboard. This is a good starter pattern to get you thinking along the lines of what can be done. It is easy to lay out and can be quite nice to look at when finished.

Figure 25. Checkerboard mosaic pattern layout.

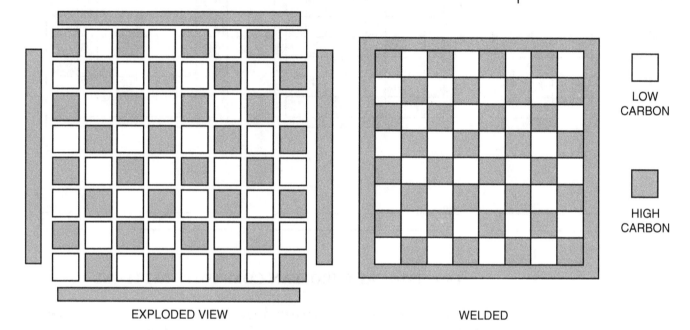

EXPLODED VIEW WELDED

LOW CARBON

HIGH CARBON

To lay out the checkerboard, all you need are some high-carbon and mild-steel square stock (1/8 to 3/16 inch is fine) and alternate them, as shown in Figure 25.

You will definitely need the high-carbon binding pieces of 1/8-inch thickness to help hold the pattern together. If you decide not to use them, then an ugly mess will develop while you are welding. Wire the whole billet together and weld, making certain that you are working the piece evenly from all four sides and that it doesn't twist or otherwise distort during the welding/forging operations.

With the billet welded, draw it down, still in the square shape, until it is the desired dimensions and ready to cut into sections.

Cutting the billet is best accomplished by using either a hacksaw or a metal-cutting band saw. Cutting hot with a chisel will only distort and "smear" the pattern. Make certain that the piece is fully annealed and has cooled to ambient room temperature before you attempt to cut it.

Cut approximately 1/4- to 5/16-inch slices off the end to expose the pattern. You will need enough slices to allow you to position them side by side to form the center section of the blade, as shown in Figure 26.

Weld these together. You may encounter some difficulty when you first start out, as the pieces are so wide in comparison to their thickness,

Figure 26. Checkerboard positioning for welding.

but work slowly and you should be alright. With the billet welded you can either wrap another piece of laminate around the outside to form the edge or you can use it as is. The choice is yours. Either way, once you understand the basic check pattern you can pretty much do whatever it is you desire.

TRADITIONAL EUROPEAN COMPOSITE PATTERNS

Contrary to common belief, pattern-welded blades were not unknown in Europe during the "Dark Ages." In fact, the Germans, Danes, Norwegians, Franks, and Poles (to mention a few) all had pattern-welded blades of some type. Perhaps the best known was the Viking family of pattern-welded swords, daggers, and knives.

I have personally examined numerous blade fragments from all over Northern Europe, and I have concluded that there were four distinct types of pattern-welded blades that were in use the most often. All are composite patterns, and this is in itself impressive, when one considers that the Vikings were a so-called "barbaric" culture. (In fact, this is far from the truth. The Vikings produced some of the finest metal work—be it iron, gold, or silver—that the world has ever seen. It wasn't until quite recently that some of the techniques of these highly skilled craftsmen were "rediscovered" and put back into use.)

These Dark Age smiths produced blades that were not only functional but, from what can be seen from surviving examples, quite beautiful as well. The patterns can be broken down into the following categories: double core, triple core, quadruple core, and built composite.

Of the blades that have been found so far, the double-core seems to have been the most common. These are the simplest to make, with the two-center core twisted and welded and the edges welded. These cores can be twisted either in the same or opposite (countertwisted) directions, uniform or interrupted twists.

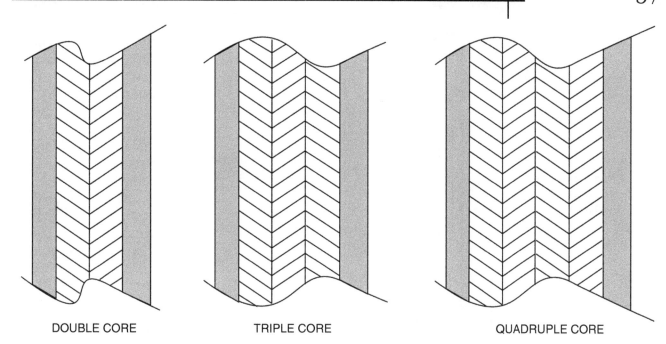

DOUBLE CORE TRIPLE CORE QUADRUPLE CORE

The triple-core twist blade seems to have been a bit more scarce, but it was still being made in sizable numbers, judging by the amount of surviving examples that I have encountered. Here again, the cores can be twisted, countertwisted, interrupted, or offset. This involves a bit of planning and can get to be a bit tedious when it comes to alignment of the pattern.

Quadruple-core blades are very complex compared to the simpler ones. They can get to be a bit complicated when it comes to planning and construction, and judging from the several that I have made, they can be a bit of a pain. But the varieties that can result are almost endless.

The most complex and difficult-to-build blades were the built composites. These blades are identified by different patterns on each side (flat) of the blade. The sword found at Sutton Hoo and replicated by Scott Lankton was forged from eight pieces of interrupted twist rods, four to a side, stacked, welded, and forged together. This is is a great deal of welding in itself, not to mention all the hours of preparation prior to the actual construction.

These built blades can be made with as many as twelve pieces to as few as three, not including the edges. The variety of patterns are amazing, but all of them require careful planning and a thorough understanding of the pattern-welding process from start to finish.

Regardless of the type of construction, all of the blades that I have examined seemed to have welded-on edges, which I refer to as a "steeled" edges. More often than not, these edges were pattern welded with a straight laminate, but I cannot be certain because the surviving examples that I've examined were badly corroded, though the blades were identifiable as to construction.

The patterns on the vast majority of blades seemed to be based upon twisted-core laminates. These twists could be uniform (both in rate of twist and direction), reversed twist, interrupted twist, interrupted/ reversed, or any variation of most any twisted pattern. Most were either uniform twist or inter-

Figure 27. The three most common types of traditional European constructions of pattern-welded sword blades.

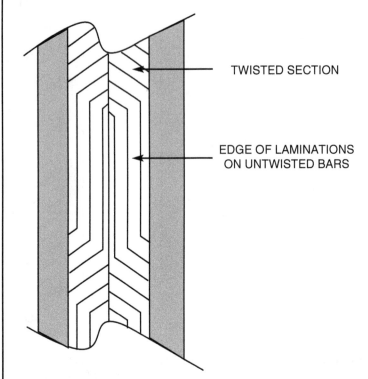

TWISTED SECTION

EDGE OF LAMINATIONS
ON UNTWISTED BARS

Figure 28. In order to reveal the straight sectional patterns, you must properly align the edge of the laminations to be exposed on the blade's flat.

rupted twist blades. In the case of the interrupted twist, the cores were twisted and positioned so the edge laminates would be visible on the blade surface, as illustrated in Figure 28.

Before I proceed, I must state that what I am about to discuss, while based on years of exhaustive research and countless reconstructions, is, on the most part, educated conjecture. Although I have examined dozens and dozens of blade fragments, I have by no means examined every one that has ever been made, so please understand that variations are most likely to exist, as are patterns and construction techniques that I have yet to "discover."

So as you can see, some of these constructions are quite complex. While they may look more or less straightforward, they can be very difficult to get to work out properly.

Getting Started

The basis of these types of patterns are, again, the straight-laminate billet. This type of construction can use up a lot of pattern-welded material, so be prepared to make more than you think.

Traditionally, the center cores of most blades were very coarse by most pattern-welding standards. I have had excellent results with as few as 7 layers and as many as 75. Remember that the more layers you have, the finer the pattern will be.

If the pattern is to be uniform, all cores must be as uniform as possible. Again, I suggest that you cut them from a single piece. If you are doing a hybrid pattern such as two twists around an undulating center (a very common pattern for this type of blade), then the outer cores must be identical while the center core can be of a different material or layer count. The more attention to detail at this point will result in a better patterned blade in the end.

Remember that uniformity is the key element in getting a pattern to work correctly. I have examined several pieces of blade fragments that seemed to be made by splitting lengthwise pieces that were twisted prior to splitting. I came to this conclusion by the fact that the patterns were "book matched," i.e., identical to the very last detail. Splitting is the only way that I know of to achieve this.

WELDED/TWISTED
CORE CUT THREE-
QUARTERS THROUGH
WITH CHISEL.

OPEN SPLIT

EDGES CLOSE

INTERIOR OR CORE
FORMS NEW FACE.

WELD "EDGES" TOGETHER TO
FORM THE RECTANGULAR
CROSS SECTION CORE.

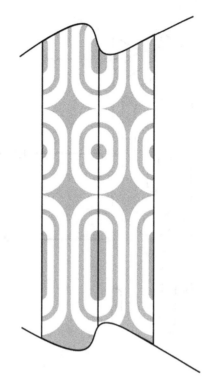

Figure 29. Splitting a core lengthwise will result in a mirror image on the "inner" surface (interior section) of the bar.

Figure 30. Split the prepared core lengthwise, cutting with a hot chisel approximately three-quarters to seven-eighths of the way through. Open the split, causing the edges to "close together," and weld them shut.

To split these bars, I suggest they be cut with a band saw. Traditionally, these would be split with a chisel, but this would have to be followed up by reforging into a square shape in order to get a solid weld surface contact.

If you are making a double-twist core without any offset interruptions, you can split with a chisel 90 percent of the way through, open the split, and then weld the two touching edges together (as shown in Figure 30), forge flat and true, and then steel the edge.

If you are planning to make an interrupted twist section without any offsets, simply twist the sections that you want twisted and leave the untwisted sections alone. When you split the bar, remember that it must be split on the surface of the billet, not the edge, as this bar will be rotated when the cut is opened and welded. This will allow the edge laminates to be visible on the blade surface.

You must also make certain that the edge positions of each straight section are the same. If not, you will have an unpatterned section appear where the flats of the laminate are on the blade surface.

Getting back to the matter at hand. Weld your center core billet using at least 7 layers and no more than 64 for the finer patterns. I use between 7 and 28 layers for most of my work. These give a decent pattern and the best contrast, in my opinion. Now cut your center cores, straighten any curves, and you are ready to go.

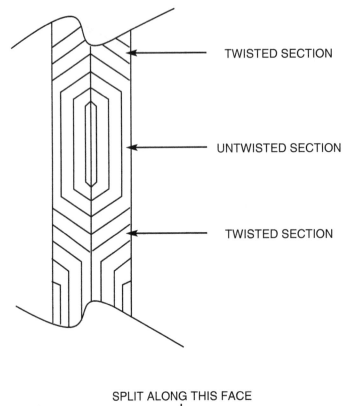

Figure 31. When cutting a single core, make certain that the straight (untwisted) section of the laminate's edges are in the same plane or else an "empty" spot will appear in the finished blade.

TWISTED SECTION

UNTWISTED SECTION

TWISTED SECTION

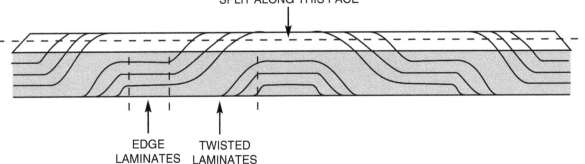

SPLIT ALONG THIS FACE

EDGE
LAMINATES

TWISTED
LAMINATES

Construction of a Basic Double-Twist Cored Blade

You will need to weld up enough material to make the center cores, with another billet to forge the edge steel. Do not weld the edge steel billet until the center cores are patterned and welded together, since you will have no idea as to how much edge material you will need at this point.

I suggest that you weld up a billet of seven layers to start out, progressing to a higher laminate count once you become familiar with the process.

Forge out two square cores of approximately 3/8-inch square. These cores need to be as identical as possible at this point. The length should be approximately three-quarters of the finished length, more or less, depending upon the desired pattern and your experience. A good length to start is in the 18-inch range. This gives you enough to get a decent blade pattern without too much difficulty in handling the piece while you are working.

With the rods ready, you will need to decide on the type of pattern you desire. The simplest is the chevron twist core. To do this, simply twist and

countertwist the rods. You can twist the cores tightly for a very close pattern or more gently for one that is a bit open. Regardless of the type of twist you choose, they should be as even as possible for the best pattern to result.

I have had the best patterns with very tightly twisted cores. Remember that these will tend to straighten out when the forging and welding is completed.

Using the Twisting Jig

This is a very easy tool to use, and it is pretty much self-explanatory, but assume nothing and you will be a lot better off.

First, set the distance between the jaws to the desired length and tighten the set screws to secure the setting. Next, firmly anchor the jig in a post vise next to the forge and then adjust the jaw thickness to the workpiece.

You do not want the jaws to grip the piece. Rather, you want the piece to drop in yet remain tight enough so that it doesn't turn when the twisting starts.

The distance between the two twisted sections will only be as wide as the jaws of the wrench used for the actual twist. To get various lengths of straight laminate between the two sections, you will need to make a "twisting spanner" (Figure 32) for each thickness of bar and for each length of untwisted area. The jig and spanner combination allows you to get quite creative with patterns, and it does save a lot of time and hassles in trying to get the lengths correct and the twists evenly spaced.

With the tooling ready, you are set to go.

Take a high heat (bright cherry red or hotter), place the section to be twisted in the jig, set the wrench to the center (or anywhere you desire for what you have in mind), and pull (or push, depending) the wrench back a

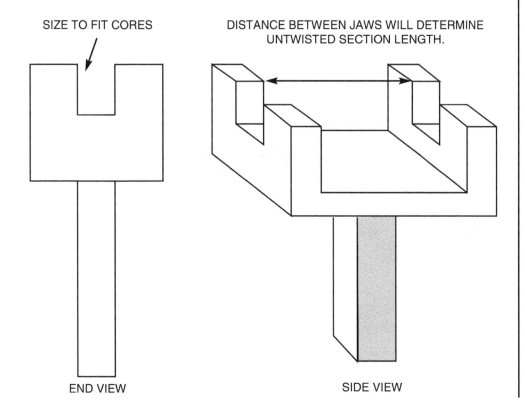

SIZE TO FIT CORES

DISTANCE BETWEEN JAWS WILL DETERMINE
UNTWISTED SECTION LENGTH.

END VIEW　　　　　　　　　　　　　　SIDE VIEW

Figure 32. The spanner wrench can be easily made from 1/4 x 1 1/4-inch high-carbon steel and can be made in a variety of sizes and lengths for most patterns desired.

half turn. You will notice that two opposite twists are forming in the piece, one on either side of the spanner. Continue the twist by removing the spanner, repositioning, and repeating the same motion. It only takes two or three cycles to get most lengths twisted.

If you do not desire the twist/countertwist pattern, then do not use this tool. Twist as usual with a twisting wrench.

You can very easily overtwist and shear the piece using this jig/spanner setup. I strongly urge you to practice with several different sizes of mild steel and in different twist lengths prior to using laminated material.

When you are done with the twist, make certain that the edge laminates are in proper alignment with the rest on the bar, as it is all too easy to miss this step, and that can be disastrous in the finished piece.

With the rods twisted, forge them into a rectangular section. It is hard to gauge the exact size of rectangle that you will need, given all the variables, but together the center core should make up approximately two-thirds of the blade width. I suggest that you make them no thinner that 1/4 inch in thickness. If you wish to have the edge laminations visible on the blade surface after the blade is complete, then you will have to forge the edge laminates down, not on the face. You will need to augment the rods when you are flattening so they will remain more or less identical.

I strongly suggest that you do this flattening at a welding heat. This will help to weld any weld shears that may have occurred during the twist. Work each bar in turn, and try to keep them uniform both in thickness and width. The more attention to detail and careful workmanship at this point, the better the results.

When the bars are flattened into rectangular cross sections, fit them together as closely as possible. You want a very close fit, as the better the fit,

The patterned, straightened, and fitted cores are properly positioned and wired together prior to welding. Here again, the wires will be removed during the weld process. (Photo by Gary Thompson)

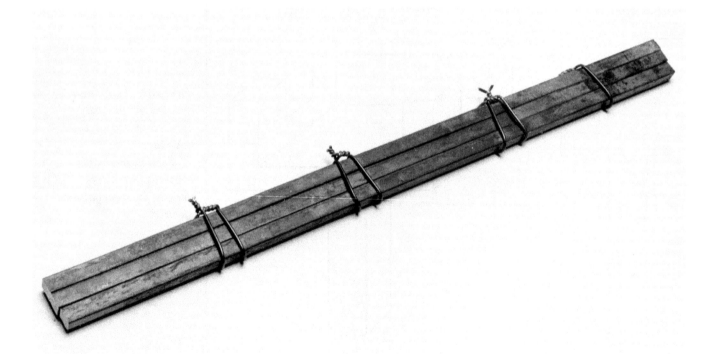

the better the welding will be. (This close fit is almost an absolute requirement for success in welding three, four, or built-composite cored blades.)

With the cores fitted, grind the mating surfaces clean on a fresh 40-grit belt. I grind these at an angle to the length of the billet, as I feel that this helps the flux penetrate into the weld surfaces.

Now position the cores together, making certain that the edge laminates are properly aligned and that this is the way that you want it to be. If you make a mistake at this point, you cannot go back and redo this.

When you are satisfied that the bars are properly aligned, wire them together as shown in the photo. Whatever you do, *do not* tack-weld them together prior to the forge weld.

There are two reasons why you shouldn't do this. The most important one is that the welding rod "filler" will cause holy hell with the pattern. The second reason is that as the cores start to heat, they may expand (they more than likely will) at different rates. This can cause the weld bead to break, and this may cause the pattern to shift. While this is not that disastrous with a double-core blade, it can spell ruin for the more elaborate patterns discussed below.

Start the weld at the tip, paying close attention to the tip shape. You want to keep the cores in proper position while welding, because if they shift one way or the other, the pattern will appear to be "off" when the blade is finished.

Weld the tip, making certain that the weld is sound, and work the flat of the blade as well while still at a welding heat. You want to flatten the welded area slightly to compensate for the compression of material during the actual welding. You will be stretching the blade length slightly as well as reducing thickness while you are doing this.

Work your way down the core until it is welded. Depending upon your equipment and the length of the cores, you may have to reverse ends to complete the weld. There is nothing wrong with doing this; I do it with every sword I weld.

While you are working, take shorter (3 to 5 inches) welding heats and overlap the last 1 1/2 to 2 inches welded. This way there will be less of a chance of a cold shut. Remember that you need a perfect weld, with no cold shuts or slag inclusions. If the weld opens while you are flattening it, reweld at once and then proceed to the next heat.

Keep the cores straight and in position throughout the weld process. When the core is welded, true it up. Make certain that it is not twisted or curved. Work both sides and both edges of the core. This way you will not overwork one edge or side, which will throw off the pattern.

Special attention should also be paid to the core tip. This should be forged into a nice rounded shape to allow the welding of the edges to take better. This way when it comes time to steel the edge, this round tip will make for a weld that is both more pleasing to the eye and somewhat easier to accomplish.

When you are satisfied that the core is straight in both planes, let it air cool and start on the edging material.

The edge is simply one long piece that is wrapped around the blade. It can be a pattern-welded laminate, straight laminate, or a medium-carbon, homogenous steel such as 1060, 5160, or L-6 (actually you can

use just about anything as long as it is weldable and has enough carbon to harden properly).

If you are using a laminate for the edge, you will need to weld up enough material to forge out a strip approximately 3/16- to 1/4-inch thick and 5/16- to 3/8-inch wide, depending upon the width of the core and how wide you wish the blade to be.

You will be welding around the outside of the core, so you must have enough material to do this. To measure, simply use a flexible tape and measure the core from the base around the tip and back down toward the base again. I usually leave approximately 2 to 4 inches of the core unedged to allow for tang forging.

Figure 33. Start the bend by lifting the ends of the heated edge toward the blade core.

To snug the core into the edge, drive it down onto the anvil while still at cherry-red heat. Heat the edge only; do not take a heat on the cores.

With the edge/core together, wire securely to prevent shifting.

When you have the material ready for steeling onto the core, you will need to refine the core tip (if necessary) and grind the outer edge of the core and the surface of the edging to be welded clean and free of all scale, slag, or other impurities.

Take a dull cherry red heat on the center of the edging, place the core on top, and bend the edging up around the core, as illustrated in Figure 33.

As you can see, the edge should fit snugly around the core. It can be done in one heat, but most smiths' first attempts may take two or three heats in order to get this right. You want to make certain that you have a good, solid fit on the core. When this is accomplished, let air cool and wire the core and edge together.

I suggest that you use a series of wire bindings spaced no closer than 3 inches and no farther than 5 inches apart. This way there will be enough bindings to support and help keep aligned the core/edge while you are working. You will be cutting off these bindings as you weld your way down the blade.

With the blade wired, you are ready for the final weld. Start at the blade tip; this way, if the edge stretches, the steel will simply lengthen down the blade toward the hilt end, causing no difficulties whatsoever. If you were to start the weld at the hilt end, the edging may stretch and cause a nearly impossible-to-correct gap at the tip. I know, because it has happened to me.

The tip weld is the most difficult part of doing this type of blade construction. It takes some getting used to, but once you do a few, they do get easier.

The big difficulty is the hairpin shape. You will be making a weld that is, for the lack of a better term, a U shape. For many smiths, it is the first time they will be doing this. It all comes down to proper hammer placement and the correct striking order.

Since this is the first and most important weld, you will not need to take a very large welding heat. I suggest that you heat only the first two inches of the tip, which should be enough of an area to allow for the welding of the entire tip. This is the most critical part of doing this.

Bring up to heat, flux, and finish up to a welding heat, and you are all set. When the tip is up to temperature, place the hilt end of the blade down onto either the floor or anvil face (depending upon blade length), hold the blade vertically, and strike the first blows straight down on the end of the tip, as shown in Figure 34. Be sure to wear adequate eye/face protection.

You do not need to strike a very heavy blow; rather, a medium tap should do it. If you strike too hard,

Figure 34. To set the tip weld, strike the first blow directly onto the tip, followed quickly by blows two and three to finish the weld. Make certain that the core/edge position remains unchanged.

you can deform both the edge and the core, so strike no harder than required to get a good, sound weld.

Next, place the tip edge down onto the anvil face, holding the blade at an angle, and strike the area closest to the welded area of the tip. When this is done, flip the blade and repeat for the other edge. Work quickly, as this should be done in one heat.

Repeat this angular hold until the tip is welded. You have only a few seconds to do all this, and it does go rather quickly. I can easily weld a tip in one heat, with enough heat left to true up the tip as I go. It just takes a little getting used to all the fancy moves and holds.

NOTE: Special care must be taken to ensure that the blade core remains properly centered between the edges. If not, then you will have an off-center pattern when the blade is finished.

As I am welding the tip, I work the flat of the blade as well. This way you will help to maintain proper alignment of the core/edge and

Figure 35. After the tip weld is set, strike the tip on its edge to continue the weld. Flip over onto opposite edge and repeat.

With the piece at a welding heat, strike the flat of the blade as indicated here to help force the edge of the core into the edging. Flip over and repeat.

Go back again and work the tip as shown, alternating edges to help the core "upset" into the edge material. When completed, continue to weld down the billet, making sure to maintain proper alignment of the core and edge.

keep the core running down the center of the blade. Also, this flattening will help to "force" the core out to meet the edging at the tip.

With the tip welded, I usually finish forge the tip to the end shape prior to welding further. This way I have a guide to work from. Of course you can simply weld the entire length prior to final shaping, but I like to work these to shape as I go. I feel I can do a better job this way.

With the tip welded, start to work your way down the blade, overlapping the weld area as you did when welding the core. You must make certain that you are getting 100-percent perfect welds. If you have any doubts, wire brush clean, reflux, and take another weld on the suspected area.

This is very hard work and quite intense. Face it, with most patterns the welding area is 12 inches or less. This is a very long weld, the entire blade length, twice, when you consider that the core was welded prior to the edging. And on a 3-foot sword, this is some serious work, so don't try to rush through it. The more attention to detail the better the results will be.

As you are working you will notice that the core/edge will have a tendency to curve a bit. This can be prevented by simply alternating edges as you weld. Also, remember to clip off the bindings as you work your way down the blade.

When you get toward the end, on the second to the last weld start to work the edge ends as well. This will keep them close to the core and in proper position. This is a good deal of work, and you don't want to have to start over because the edge/core shifted. Remember to try to keep the core centered in the blade.

If you are working the blade to final shape while you are welding, the last weld will mean that the blade welding is more or less completed. If not you will have to go back, starting at the tip, and finish forge the blade prior to any fullering and edge packing.

All of the pattern-welded broadswords were fullered, and that is the next step. When the fullering is complete, anneal and finish into the completed blade.

THE MORE COMPLEX PATTERNS

These blade patterns are basically variations of the two-core theme. Some of them, while complex, are well within the capabilities of most smiths. While it is difficult to even attempt to describe all the different patterns, I can discuss the methods of working the center cores that,

A double-core dagger in the Viking style made by the author. Blade materials are 1095 and pure nickel; high-density laminate edge of 1095 and wrought iron. Mounted with bronze and buffalo horn. (Photo by Gary Thompson)

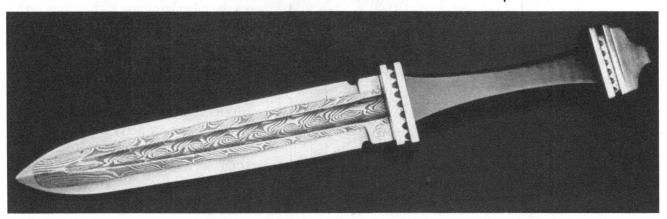

Detail of a traditional three-core twist/counter-twist (uniform) blade section made by the author. Materials are 1095 and wrought iron with high-density laminate 1095 and 1018 on the edges. (Photo by Dan Fitzgerald)

when understood, will allow you to work these different cores into the various blade patterns.

(All of these blades have steeled edges and should be welded and trued up prior to steeling. Here again, the edges can be either a homogeneous carbon steel or pattern welded. You can get even more complex by using a ladder or some other surface-manipulated pattern-welded material for the steeling.)

On the triple- and quadruple-core blade, you will need to understand that these "extra" cores give you more opportunities to experiment with different variations, as pictured in the photo. Here you can see that the three cores are

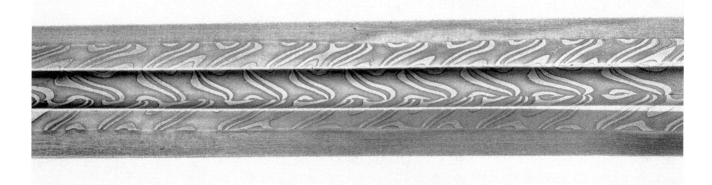

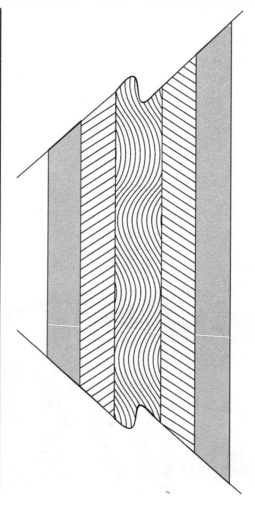

Figure 36. The serpent pattern of three-core construction.

twisted and countertwisted, alternated, and the edge welded on. This is the next step in doing this type of construction. Again, rod position is very important. This was a very common method of construction, as far as I can tell.

The serpent pattern is a composite pattern comprised of two outer twisted/countertwisted cores, one on either side of an undulating center core. To make the serpent core, cut ladder grooves in the center core, flatten as in a ladder pattern, and then form into a rectangle, working so the edge laminates are visible on the long surface of the rectangle.

When you have the cores completed, simply position and weld. You need to make certain that the edges of the center core are visible on the flat of the blade in order for this to work properly.

The serpent is a very old pattern, and this type of blade was referred to in at least two different Norse sagas.

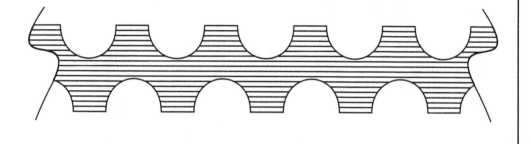

PARALLEL TO LONG FACE BECOMES PARALLEL TO SHORT FACE.

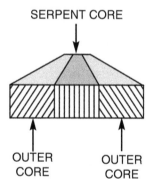

Figure 37. Cut grooves as in a ladder pattern and then flatten.

Next, forge from the flattened rectangle, with the laminates parallel to the long face, into a rectangle, with the laminates parallel to the short face.

The most intriguing of these type of patterns, at least in my opinion, are the interrupted twist patterns. These can be aligned, offset, or a combination of the two.

Here the rods are twisted/countertwisted with the twisted sections evenly spaced and matched. You will need additional planning in order for this to work properly. I work these patterns out using two different colors of modeling clay; this way I have a better idea as to what is happening inside the bar.

To lay out the twisted/untwisted sections you will need to remember that the twisted sections need to be approximately two times as long as the untwisted sections. While this seems odd, it makes sense when you realize that the first 1 1/2 and the last 1 1/2 twists appear the same as the straight sections.

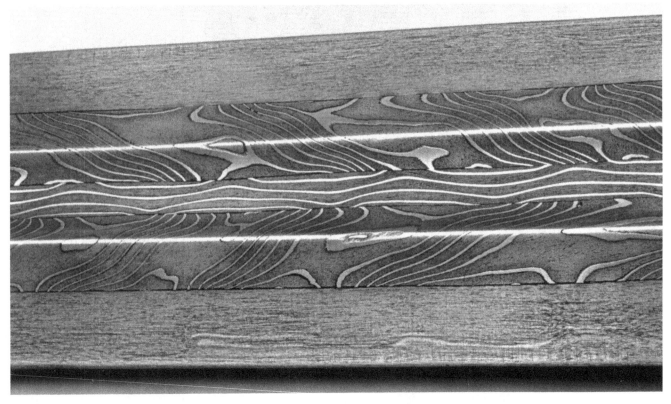

The serpent pattern is another type of triple-core blade made from two twisted and one untwisted core. This blade was forged from 1095 and pure nickel by the author with a high-density laminate edge of 1095 and wrought iron. (Photo by Gary Thompson)

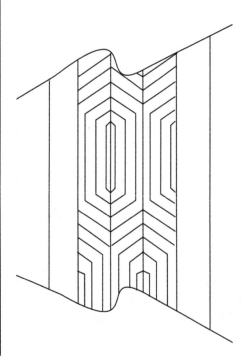

Figure 38. Triple-core interrupted twist, aligned.

It is also important to be sure that the edge laminations are oriented properly and are in the same plane throughout the entire length of the bar. This way you will not have a "disappearing" pattern on the blade surface.

You will need to make three identical bars. Make certain that the lengths and twisted/untwisted areas are the same. Also, the amount of twist in each section of each bar should correspond to the others. Uniformity is very important in patterning such as this.

When the bars are twisted, forge into rectangles, position, and weld together.

When you are positioning the bars, remember that you will need to keep the pattern even and the rods positioned properly. If the rods are of slightly different length, align the tip of the core and let the tang area suffer the misalignment. This way any misaligned patterns will not be seen, as they should be covered by the guard/grip.

Now weld the core together, flatten, true, and then steel the edge.

An interesting variation on this pattern is the offset interrupted twist. Here again, it takes some

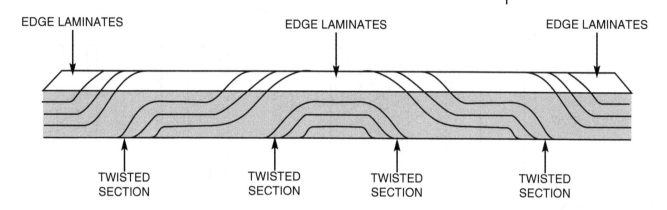

EDGE LAMINATES EDGE LAMINATES EDGE LAMINATES

TWISTED TWISTED TWISTED TWISTED
SECTION SECTION SECTION SECTION

thinking out to accomplish properly, but the results are well worth the effort.

As you can see in Figure 41, the three cores are offset twist/ countertwist on the same core. This does tend to get a bit confusing, so I suggest that you do the center core and then work the two outer cores, twisting each section on both cores before proceeding to the other twisted sections of each core.

You will note that as long as the two outer cores are positioned properly in regards to each other, you can be off as much as a full twist with the center core and the pattern will still look alright. Make certain that the twisted sections are as close to being identical with the corresponding sections of the other bar. You do have some freedom in regards to the center core as long as you are consistent with the two outer ones.

Layout of this pattern is very important, as is the alignment of the edge laminations on the cores. The cores must also be as straight and true as possible in order for this to work correctly.

When everything checks out as far as the twisted/countertwisted sections go, start to flatten into rectangles, position (from the tip of the core, not from the hilt end), weld/flatten, and true. Steel the edge.

Four-core blades are another "fun" way to express yourself. I am certain that the smiths of old looked forward to giving these as much beauty

Figure 39. When making the core, be sure that the edge laminates remain in the proper plane.

Figure 40. When positioning the core prior to welding, make certain that the twisted sections meet as closely as possible. Secure together and weld, making sure that the core position does not shift during the welding process.

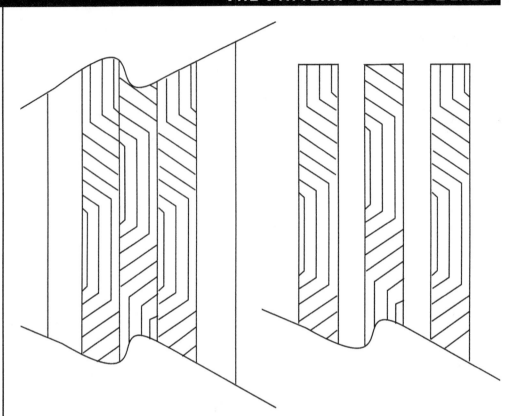

Figure 41. Triple-core interrupted twist, offset.

Figure 42. On the offset twist, match the pattern at the blade tip section and position the cores as shown. Secure together and weld. Here again, take care to maintain proper core position during the welding process.

Section of a three-core interrupted and offset twist/countertwist blade made by the author. The two outer cores are aligned; the inner core is offset. Materials used are 1095 and 1018 with a high-density edge laminate of 1095 and 1018. (Photo by Dan Fitzgerald)

as they could. I have found two blade shards that were made with four cores, so while they were rare when compared to the two- and three-core methods, they were not all that unusual.

The fact that you are dealing with four separate cores allows you to experiment with not only offset/interrupted twists, but reversed patterns and more elaborate combinations as well. As always, careful attention to detail is required.

When you are working these cores, work along the same lines as with the three cores. The only real difficulty you may encounter is possibly having the pieces shift during the welding. I strongly recommend that you try to keep the cores as straight and as flat as possible. This way you will keep distortion to a minimum, resulting in a better pattern. You are limited only by your imagination.

Built-Composite Blades

Built-composite blades are perhaps some of the most complex and troublesome patterns that man has ever welded. The Sutton Hoo sword is

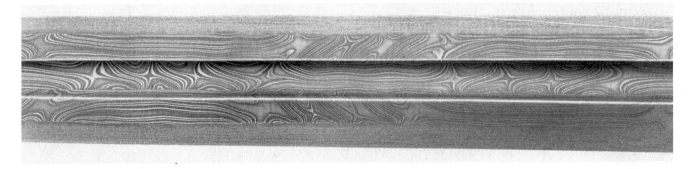

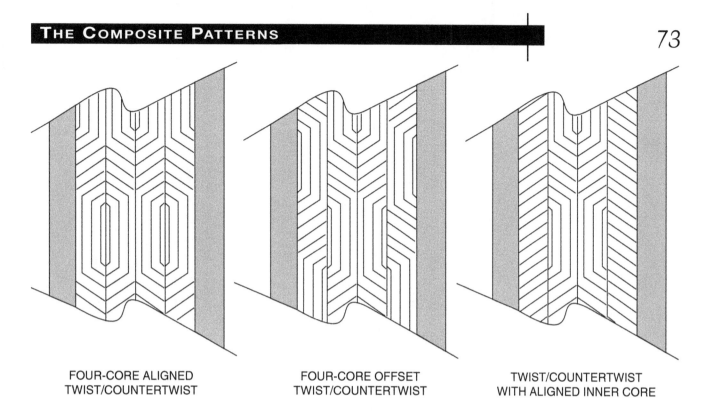

FOUR-CORE ALIGNED
TWIST/COUNTERTWIST

FOUR-CORE OFFSET
TWIST/COUNTERTWIST

TWIST/COUNTERTWIST
WITH ALIGNED INNER CORE

a fine example. It has been studied by archaeologists and historians alike and was recently copied by Mr. Scott Lankton, a rather well-known blade-smith working in conjunction with at least one British museum.

Figure 43. Traditional four-core blade constructions.

The complexity of this sword is downright amazing. It consists of eight interrupted twist cores, four on each side of the blade. These cores are offset from side to side so that each flat has the twisted sections in different positions on each side of the blade. And to make it even more difficult, the cores were tapered prior to welding! This was not a "common" sword; rather, it was, as far as anyone can tell, a ceremonial funerary sword entombed in a ritual burial. It was, more than likely, the finest work available at the time. After looking at it, I agree.

As you can see in Figure 44, the construction of this particular sword is very complex. It is quite an undertaking to weld eight cores together, four on a side, in one heat. I would rather do it in two courses, welding each side separately, and then welding the two together, but, even doing it in this manner, it is still a great amount of work.

Most built-composite blades were not this complex. The more common Frankish styles are illustrated in Figure 45. Regardless of the type or styles, these composite patterns are some of the most difficult and beautiful of all pattern-welded steels.

■ ■ ■

There are numerous patterns yet to be discovered, and no man could possibly list them all. Experimentation and an intimate understanding of the pattern-welding process are the keys. With these, you can do most everything. You are only limited by your imagination.

Figure 44. The sword found at Sutton Hoo was an eight-core sword of interrupted twist-pattern; however, the pattern was offset from one side to the other.

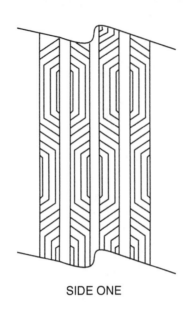

SIDE ONE

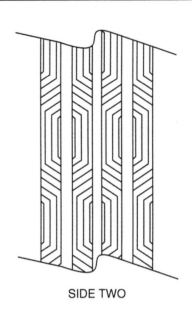

SIDE TWO

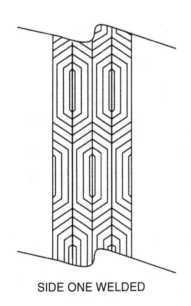

SIDE ONE WELDED

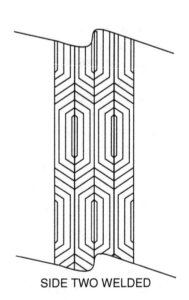

SIDE TWO WELDED

Figure 45. Numerous examples of Frankish-style blades survive in a good-enough condition to determine how they were constructed.

5TH C KNIFE
CROSS SECTION

3RD C SWORD
CROSS SECTION

3RD C KNIFE
CROSS SECTION

3RD C AXE
CROSS SECTION

All I hope for is that when I pass from this mortal plane, I leave behind a legacy of knowledge and artistry, so that when I face those smiths of old—Tubal Cain, Andre Farrarre, Assad, and all who have gone before me—I can hold my head high, knowing that I have done my best.

Welded Cable

There has been a constant interest over the years in using wire rope (steel cable) for welded blades. Some makers refer to it as welded wire, wire Damascus, spiral-pattern welded, and numerous other names. No matter what it is called, it still remains simply welded wire rope/cable.

I have done countless blades from this material, and I am still amazed that it welds as easily as it does. All those small-diameter wires with all that airspace in between simply "want" to weld. And weld they do. While the pattern is more or less a spiral arrangement, you can get some rather interesting variety by playing around with both the material and the process.

Starting out to weld a cable blade is simple. Get a clean welding fire and go to it. But first you will need to get the proper material for welding.

CABLE TO USE

First and foremost, *do not use any cable that has been plated!* This can be deadly! Galvanized cable produces an immense amount of highly toxic gas when heated to the temperatures that we are dealing with. So will chrome and nickel plating. You want the plain bright-finish cable.

Also make certain that the cable is all steel. You do not want any cable that has a plastic or fiber core. These will cause a mess when starting to weld.

Most cable materials are referred to as plowshare steel. This is another name for the base 10xx series steel, usually 1060. Then there are the "improved" plowshare steels: improved plowshare (1070), extra improved plowshare (1084), and extra extra improved plowshare (1095).

There are other alloying elements involved that, as far as I can tell, are proprietary. These include but are not limited to: vanadium, nickel, tungsten, and others. It seems that the companies involved in their production do not want to give out any more information than what is in a certain grade of cable. Trade secrets, I guess.

If the cable is made of wires that are the same material, what causes the characteristic spiderweb pattern? I used to believe that it was due in part to the cold-drawing process of the wires used in the cables. While this cold drawing causes the crystalline structure to align itself along the axis of the drawing direction, the crystalline structure is simply erased by the

weld/forge process. So it could not be by the cold drawing of the wire. Rather, it is the difference in crystal structure and the decarbonization along the weld seam (the wire surfaces) that allow for the pattern to develop.

Now this watering will not have the contrast of other types of welded materials, as the pattern is based on carbon differences only, but it is still interesting. The costs are low, and the materials are readily available.

The available sizes range from 1/4 inch to over 1 1/2 inch in diameter. The number of strands used in a cable will vary from 7 to over 300, depending on the type of cable you are using (see the tables at the end of this chapter for more information).

All wire rope has a petroleum/asphalt-based lubricant/rust preventative coating. This should be removed before starting in order to get the best results. I have welded cable as is with the same results, but as I have said before, why take chances?

I have tried all sorts of solvents and cleaners, and nothing seems to do the job. The best way is to take the piece apart, wire brush it all out, and put it back together.

While the pieces are separate, I like to wrap a very thin thread of pure nickel around every other outside strand before reassembling. Then I place a wrapped piece next to an unwrapped piece, another wrapped, another unwrapped, etc., until the piece is back together. This way there are no wrapped or unwrapped pieces touching.

Some makers will then weld the ends to hold the cable until the forge welding is completed. I do not like doing this for reasons discussed elsewhere, so I wire it together.

The cleaned piece of cable is wired together so the strands do not separate during the welding process. (Photo by Gary Thompson)

Now that you have the cable cleaned and wired, you are ready to start to weld.

Since the material is composed of small diameter wires, you must bring the heat up slowly and keep turning it in the fire to prevent any wires from burning and to keep hot spots from forming.

I have found it best to weld the ends first and then weld the remaining sections of the bar. Slowly bring up one end to a bright cherry red and flux, return to the fire, and bring it to a welding heat. It is very important to rotate the

piece to prevent any wires from losing the flux coating and scaling or, worse, burning.

Now start the weld. Remember, this material is all high-carbon steel. It will weld in the orange color ranges, not in the higher colors that are needed to weld the lower-carbon steels.

When the piece is ready, strike first on one side, then rapidly turning the cable one-eighth turn, strike it again. This alternate turn/strike/turn will cause the round cross section to remain more or less round.

You only need to weld the first 3/4 inch or so on each end. When the one end is welded, reverse and weld the other end. As you are welding,

you will notice that at first the piece will seem to feel soft and mushy under the hammer. It will get a more solid feeling as you progress. Also, there will be a sound change from a dull thud to a more solid ring as the hammer strikes the piece.

When the ends are welded, take a full cherry red heat to the entire length of the piece and twist the cable tightly in the same direction that it started out in. What this twisting does is tighten up the strands and reduce the amount of airspace between the wires, making welding all that much easier. I have had pieces start to weld while I was twisting, so this does work!

The degree of twist is a hit-or-miss situation. I suggest that you twist one complete twist for every 2 inches of length. I have twisted less, and while it worked, I find that the tighter the twist the better the pattern looks after all is said and done. You can, of course, twist as tightly or as loosely as you like, but I like the tighter patterns.

Figure 46. Strike and turn approximately 45 degrees and rotate in the same direction as the cable is twisted. Do this between each strike of the hammer.

With the piece twisted, return to the fire, heat, flux, and weld the remaining area. Keep turning the cable slightly to prevent squaring of the rod as it welds.

As you are welding, you will notice that the diameter of the area being welded is reduced dramatically. A 3/4-inch wire rope will forge down to a 1/2- to 5/8-inch-round section, depending upon the degree of twisting. This reduction is caused by all of the airspace between the round strands being closed by the welding process.

A great deal of slag and scale will be hammered out of the cable as the welds close. It is important that you overlap the weld areas and flux with borax. This way you can prevent any cold shuts or inclusions.

As for the rotation, I have found that the whole process works better if the piece is welded round rather than square. Welding on the square tends to set the piece up for cold shuts and inclusions in the corners. By keeping everything in the round, you are forcing the strands together in a more or less equal manner, preventing any cold shuts and inclusions.

When you have completed the weld, I strongly recommend that you again twist the rod in the same direction as the cable was originally to further tighten up the pattern and reduce any unwelded airspace. I twist these almost to the point of shearing prior to the second course of welds.

Reweld the piece after the second twist. This will close any unwelded sections, and the pattern will be quite pleasing to the eye when the piece is finished, as even the most heavily twisted piece will straighten out some during the next course of forging.

After the second welding course is completed, forge down into the desired cross section. Work at a high heat; the 10xx series steels will toler-

ate it. I forge down at a welding heat, thereby furthering my chances of welding any and all cold shuts.

This material works like any good 10xx series steel, and while it can be somewhat trying at first, once you have welded a few pieces, the whole process seems too easy to be believed.

Before you start to final forge to shape, I suggest that you debark the bar of all surface seal and slag. Some of the surface imperfections can go quite deep, so this must be done prior to forging to shape or else problems may arise when you start to grind. This can be easily accomplished by using a fresh, sharp 40-grit belt.

With the piece debarked, go ahead and finish forging the blade. It will work like a 10xx series steel, and while it is forge welded, it will seem more like a homogeneous steel under the hammer.

NOTE: If any strands open up, simply wire brush clean, reflux, and weld shut. This material is very forgiving in terms of "allowing" this to be done, more so than the more traditional pattern-welded material that can, at times, be rather difficult to correct.

Work slowly at first in case of weld separations, and once you are certain that everything is solid, proceed as usual. Since this is more or less a homogeneous steel blade, you won't have to be worried about carbon migration, although the possibility for grain growth still exists. So do the forging with the least number of heats possible, and keep the forging temperature below a full cherry red.

Ausforging this material will only improve it, as the grain structure will be enlarged due to the welding process, and it would not be refined after the weld as a traditional laminate would be by the forging out that

A finished and etched cable blade made by the author. (Photo by Gary Thompson)

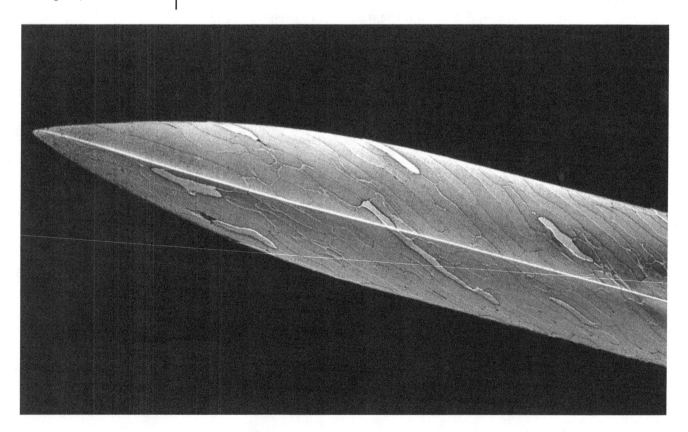

usually follows a welding course. Remember, the longer a piece stays above the critical temperature, the greater the grain growth and the weaker the steel becomes. Ausforging will fracture the larger grains into small crystal, thereby improving not only the strength but the edge-holding abilities as well.

The resulting blade will be stiff and very tough. I have done tests to destruction and have found that it is almost as tough as pattern-welded material. This toughness may be due to the fact that the wirelike structures within the blade are still present in the form of an interwoven welding seam that surrounds each welded wire, plus the fact that this material responds excellently to differential heat treatment, especially in a larger blade.

HEAT TREATMENT OF WELDED CABLE

Welded cable is prone to warpage, usually in the direction of the original twist. I have no idea as to why this happens and why only in a few pieces, but it is a problem. It is not usually noticed in a thicker, wider blade, but it is most pronounced in a slender, double-edged style. I have had blades come out of the hardening bath almost a complete spiral! So be careful when you quench, and be sure to use a vertical bath.

Since this material is prone to excessive grain enlargement, do not hold at critical temperature any longer than required for an even heating. Soaking is not recommended.

Once the blade is hardened, proceed to tempering. I have found that tempering slightly softer than usual (for the 10xx series steel that you used) results in a blade that seems to cut a bit better than if it were fully hardened. Why this is is beyond my knowledge. Maybe the other elements in the wire tend to bring out this ability. But the edge does seem to be a bit more aggressive and last just as long, if not longer.

As stated earlier, welded cable responds nicely to a differential heat treatment, being very tough and with great edge-holding abilities.

When I make a blade from this material, I harden, oven temper to a light straw color, and let air cool. Next I brighten the surface of the blade and draw a differential temper on the spine. After the blade has cooled, it is oven tempered to a light brown and left to cool to ambient air temperature.

NOTES ON GRINDING

Welded cable grinds like homogeneous 10xx series steels. It will overheat just as quickly, so be cautious and use only sharp belts.

You may notice small pits in the blade surface approximately half the diameter of a pin point. This is not uncommon. These are remaining airspaces that for some reason or another did not weld. If the pits are minute, there is no reason to scrap the blade.

Be on the lookout for small edge cracks. These seem to start at the weld seam between wires. They can ruin a blade if not dealt with immediately. If you see one starting, grind it off. While this is not the best thing to do, you can still save what's left for another project or do a last minute "design change." This cracking problem is usually not that common, but it happens enough to watch for.

TYPES OF WIRE ROPE

The types of strands and twists within the strands can (and do) get quite confusing to someone who has no idea at all about what to get. I suggest that you start out with plain, all-steel wire rope of the standard seven-strand (six around one) construction. Do not get lang lay cable, as the airspace between the strands is greater than in regular lay cable.

The wire ropes listed below are all steel and have bright, uncoated finishes. These are U.S. military (Department of Defense) specifications for the more common cable.

MATERIALS USED: Improved Plow Steel (1070)
FINISHES: Bright steel (nongalvanized)
LAY (twist direction): Right regular lay, unless otherwise specified

Number of Wires Contained in Wire Rope

The wire ropes listed below are the most commonly encountered. There are many more available, but to list them all would be beyond the scope of this book.

Type I General Purpose, Class 3, Construction 2, 6 x 37: one core with six surrounding strands of no fewer than 33 nor more than 43 wires each. Total wires: 198 to 301.

Type I General Purpose, Class 3, Construction 4, 6 x 37 (Filler Wire): one core with six surrounding strands of no fewer than 29 nor more than 37 wires each. Total wires: 203 to 259.

Type I General Purpose, Class 4, Construction 2, 8 x 19, (Warrington-Seale): one core with eight surrounding strands of 19 wires each. Total wires: 152.

Type II Elevator, Class 2, Construction 4, 8 x 19 (Filler Wire): one core strand with eight surrounding strands of no fewer than 21 nor more than 25 wires in each strand. Total wires: 168 to 200.

Type II Elevator, Class 2, Construction 5, 8 x 19 (Warrington-Seale): one core strand with eight surrounding strands of 26 wires each. Total wires: 208.

As you can see, the total number of wires used varies greatly, from 152 to over 300. The more you start with, the finer the pattern. If you fold the bar, the pattern will be quite subtle. This subtleness can be very pleasing, but I like the more dramatic patterns. That is why I augment this material with the pure nickel strips.

Like almost everything else in bladesmithing, individuality and experimentation are the only way to truly learn this craft. Feel free to try new things, and you may be delighted with the results.

Grinding the Blade

No matter how good you are at forging a blade, it still has to be ground. Grinding does several things: first it cleans up any errant hammer marks; second, it exposes clean, scale-free material on the surface; and third, it allows for edge bevels and refinement of the blade shape and design.

The amount of grinding should be minimal. You only wish to remove the outside scale and finish/shape both the profile and the edge bevels. Face it: the more a pattern-welded blade is worked hot, the better the pattern.

The three basic grinds of hollow, flat, and cannel should already be understood and mastered before you even attempt to weld any blade. In case you still are not familiar with them, I strongly suggest that you master them before proceeding.

As I discussed in Chapter 4, the type of grind will affect the pattern. Here are the effects.

FLAT GRINDING

Flat grinding simply cuts through the laminate, exposing layers in a more or less even "banding" pattern. This will appear as even lines on a straight lamination and more or less even on most other patterns.

HOLLOW GRINDING

Due to the fact that it is done on a radius, hollow grinding will tend to show wider banding at the bottom of the grind (near the edge) than at the top of the grind line (near the spine). This can be quite evident in some patterns, especially those based on surface manipulation such as the ladder pattern or hugs and kisses. Most material manipulation patterns such as the various twists seem to remain more or less unaffected.

CANNEL GRINDING

This is also known as appleseed, convex, and a few other names. This grind is simply two large arcs starting at the back (spine) of the blade and meeting at the edge.

The effect on the pattern will be almost opposite that of a hollow grind. The laminations will appear to be thicker and coarser along the spine where the grind starts and then seem to get finer more toward the edge. While this should be the case with all blades forged to shape, this type of grind will bring this out even more.

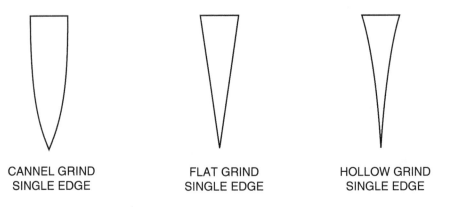

CANNEL GRIND FLAT GRIND HOLLOW GRIND
SINGLE EDGE SINGLE EDGE SINGLE EDGE

Figure 47. The three most common grinds for blades in both single and double edges.

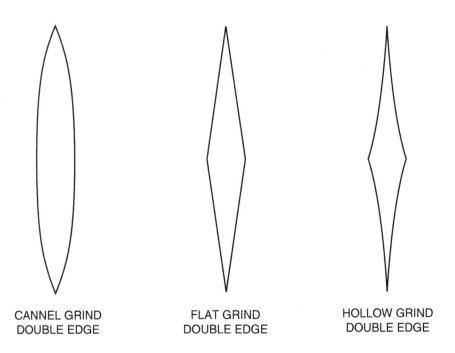

CANNEL GRIND FLAT GRIND HOLLOW GRIND
DOUBLE EDGE DOUBLE EDGE DOUBLE EDGE

BASIC GUIDES FOR GRINDING A PATTERN-WELDED BLADE

While the techniques themselves remain fairly constant whether you are grinding high-carbon or pattern-welded materials, there are some things that should be kept in mind while grinding a laminated blade.

The first one is to keep the blade cool. This is very important, especially when using such thermally diverse materials as pure nickel and anything else. Most laminate materials—due to the fact that they are, after all, different alloys—expand and contract at different rates. These differences can cause severe stress buildup in the blade, and the blade can and often does crack if one is not careful.

You can help keep the blade cool by repeatedly dipping in water and by using new, sharp belts on the grinder.

You will notice that most combinations of laminates tend to grind more quickly than homogeneous blades. This is partly due to the fact that half of the blade is nonhardenable, and even in a fully annealed state, nonhardenable steel is softer than a hardenable alloy.

Also, make certain that the blade is fully annealed and dead soft prior to grinding. If not, then you run the risk of excessive stress and cracking during the grind.

You should grind the minimum amount to allow for proper pattern development and exposure. In other words, you should perform the maximum amount of shaping and edge packing while the blade is hot and before annealing and grinding.

The design of the blade as well as the specific pattern should be taken into consideration prior to the start of the grinding process. Some patterns are better suited for a cannel grind, while others look best flat or hollow ground. Here again, experience will help in deciding which grind style looks best with a given pattern and blade style.

A cannel grind is best suited for a single-edged blade. While double edges look good flat ground, they really stand out when they are hollow ground. The center spine really jumps out at you. But the choice is up to the individual maker.

If possible, I strongly urge that you do approximately 75 to 80 percent of the grinding prior to hardening/tempering. This will give you some room for correction of any errors or warpage after heat treatment.

Grind slowly, using a sharp belt, and cool often to prevent cracking. Laminate materials are more prone to warpage and cracking than homogeneous blades, so be on the lookout for trouble. You can minimize bending by trying to grind the blade evenly. This is done by grinding the edge bevels in stages rather than grinding one bevel completely before grinding another.

To minimize cracking in heat treatment, make certain that the profiling grinding marks run lengthwise along the edge, *not* across it. Also, I recommend that you grind to 180/220 grit or finer prior to hardening to help reduce the chances of cracks being generated by the larger grit marks running in from the edges.

Other than these guidelines, grinding a laminated blade is more or less the same as anything else. You just have to be a bit more cautious.

When the blade has been ground, heat treat/temper and do the final grind.

FINAL GRINDING

This is where the blade takes on its final shape and grind. You should be able to remove any surface decarbonization/scale with little difficulty

and get the whole blade shiny and bright. I use a 120-grit belt followed by a 240 for the "prepolish."

The 120 grit is still coarse enough to remove a good deal of material without undue heating and the problems that arise from that. You can use a coarser grit, but I have noticed that if you do, you run the chance of causing an uneven etch. This unevenness will look like grind lines on the finished blade. Even if all the coarse grind marks are removed and fully smoothed and polished, they can "magically" reappear and really mess up the blade.

What these lines are are stress marks caused by the larger grit particle causing uneven pressure on the blade surface. Smaller grits—due to the fact that they are finer and hence the distance between cutting angles on the crystals is less—do not seem to have this detrimental effect on the surface. So if these grind marks appear along the edge of a fully polished and etched blade, you now know what caused them.

NOTE: It is easier to fully finish grinding any flat surfaces prior to grinding the edge bevels. In doing this you help eliminate any grinding flaws in the finished surfaces. While these flaws may not seem all that noticeable on a polished surface, they will show up a lot worse once the blade is etched. Work slowly and pay attention to what you are doing.

Final grind the blade and refine any edge bevels and shaping that still needs to be done. Remember that this will be the blade's final form, and all shaping/grinding will be done when this step is completed.

All edge bevels must be smooth and flaw free, as must the rest of the blade before you proceed to the finer grit.

IMPORTANT: Since the blade is hardened, you must keep it as cool as possible. Here again, repeated dippings in water or coolant will help prevent overheating. I have had blades crack from not doing this as often as I should have. Remember to try to keep the grinding as even as possible to prevent heat buildup that can cause warpage and/or bending.

With the blade final ground, go back over it using a sharp, new 240-grit belt. You must make certain that all of the coarser grind lines are removed prior to finishing it. The smoother the surface is at this point, the easier the finish will be and the better the results.

You will notice that on a flat- or hollow-ground blade, there is a tendency for the grind line to want to "roll over." Be careful of this. It seems that, for some reason, a welded blade is more prone to do this than a homogeneous one. Why this is the case I have no idea. It may be due to the fact that the softer steel is present. The softer steel would be less resistant to any off-pressure than the harder heat-treated layers. So make certain that you are grinding true to the angles on the edge bevels.

This attention to detail does not take long, in most cases only a few minutes. But it does make a big difference in the finished blade. No matter how rushed you are, don't quit in the middle of a step, and whatever you do, don't skip any steps or else you may have to start all over in the middle of finishing the blade.

To help see any missed coarser grit marks, I simply dip the blade in etchant for a few seconds. Any marks will become apparent immediately, and you can go back and remove them with little difficulty (this is dis-

cussed further in Chapter 9). It is easier to do this now while you are setting it up for the prepolish than to have to go back and get them later.

As with anything else, grinding takes time. Do not rush the process, grind slowly, and always wear adequate eye/face protection and a respirator.

Heat Treating and Tempering

The proper heat treating and tempering of a pattern-welded blade relies mostly on the experience of the smith. Knowing what to quench in and how to harden and temper a blade so it is both tough and able to hold a good edge is an art in itself that must be mastered by any smith, especially one who is interested in pattern welding.

The ability to harden most pattern-welded material comes from two things: experience and common sense. You must remember which steels you used in the blade, as this will more or less dictate which quenching medium you should use.

While you can oil quench a water-hardening steel, you shouldn't water quench an oil-hardening alloy unless there is considerable carbon migration that causes the blade not to harden in oil. Even then, a great deal of care and caution should be used, and the brine should be at least 185°F before quenching the blade to prevent cracking and overstressing.

Regardless of the quenching medium, the ability to get an even heating of the blade while hardening is an absolute must. But what about the differential hardening that is so touted by the bladesmithing community? Once the blade is hardened, you draw back the spine to a softer temper; not dead soft as with carbon steel, but more to a stiff spring temper.

The reason for doing so is this. When you harden the blade, the carbides "freeze" into needlelike structures, causing the steel to harden. This hardening will affect the etch, and if there are any unhardened areas, these will etch differently and appear off when compared to properly hardened sections of the blade. When you draw the temper, even though you are annealing the steel, it will still retain enough hardness to etch more or less evenly with the harder, cutting portions, that is as long as you do not fully anneal the softer areas.

In all honesty, I can see no reason why you would want to fully anneal the spine, etc., since a properly hardened and tempered pattern-welded blade really doesn't need to be drawn back to the same point as the more brittle carbon steel. But after all, the choice is yours.

Most carbon steels harden when heated to approximately 1450 to 1700°F and then quickly cooled by immersion in either oil or water (depending upon the steel in question). While it does take some practice to get an even heat the entire length of the blade, it should be of little diffi-

culty for most smiths, although sword-length pieces can be a bit trying.

In addition to an even heat, you will need a tank of the proper dimensions to accommodate the blade that is being heat treated.

THE QUENCH TANK

This piece of equipment should be large enough to handle any length of blade that you plan to make. I suggest that you use a deep bath for a point-down (vertical) quench, as this helps prevent warpage during hardening. The actual tank should be made from a flameproof material such as sheet steel. If used for an oil bath, you should have a tight-hinged lid to put out any flameups.

(Although you can quench horizontally, you can run across some severe warpage. While the Japanese smiths used a horizontal quench with marvelous results, I still strongly recommend a vertical insertion into the quenching bath.)

I have several quenching baths of different sizes, but a good size for hardening most knife blades is 12 x 12 inches by 24 inches deep. This allows for blades up to 18 inches in length to be hardened, and it contains enough liquid to effectively harden at least a half-dozen blades before the bath overheats.

My sword tank is even bigger: 14 x 14 inches by 48 inches deep, fabricated from 16-gauge mild steel sheet with a hinged lid. You can make a very serviceable quench tank by using 10- to 12-inch diameter pipe (iron or steel) cut to any required length, and then weld/braze on a bottom made from 1/8- to 1/4-inch steel plate.

Regardless of tank materials, it has to be flameproof and more or less impervious to heat and flameups. Also, make certain that the tank is very stable and secure. You do not want to spill any quantity of flaming oil, as this would be a total disaster and could cause a serious, if not a total, fire.

Keep a large CO_2 fire extinguisher close at hand to deal with any severe flameups that simply covering will not handle. While all this sounds very dangerous, it really isn't as long as you don't do anything stupid and follow the proper safety procedures. Whatever happens, never, and I mean *never*, try to put out an oil fire with water. I have a large bucket of sand and a large CO_2 extinguisher close by just in case, and in all of the years I have been doing this, I have never had any reason to use them. But then again, why take chances?

Also, if you are going to use both oil and water quenches, you will need one tank for each type of bath. This way you will not have to deal with emptying and storing every time you want to use a different quench.

QUENCHING MEDIA

The most common media are water and oil. A water quench (actually brine) is a very fast quench that results in a higher degree of hardness than oil. While an oil quench doesn't get as hard as a water quench, it is considerably tougher than water.

Either will work quite well with the proper steel. Remember that most water-hardening steels will harden adequately in an oil bath. I heat

both water- and oil-hardening steels basically the same, with the water (brine) bath being used to harden blades that for some reason or another will not harden properly in oil.

For water-hardening steels, I have found that a saturate solution of simple salt brine heated to approximately 180 to 220°F prior to quenching works wonderfully well.

To make a saturate solution, heat the required amount of water and add salt to it slowly, stirring as you add to dissolve the salt. When no more salt will dissolve, you have a saturate solution.

Oil-Quenching Media

The oil quench is far more commonly used in the modern bladesmith shop. It can effectively harden most steels, including some of the water-hardening steels. There are several types of oils that can be used: organic, synthetic, and petroleum based.

Organic based includes some of the finest oils available and also the most costly. Olive, vegetable, and corn oil work very well, as does whale oil (though it is no longer available) and fish oil.

Fish oil is very expensive and it smells to high heaven, but it does work. It is a medium-weight oil with a not-too-fast cooling rate. Fish oil goes rancid quickly, and that really has an unforgettable aroma.

Olive, corn, and vegetable (Canola, aka rapeseed) oils also work well. They don't smell all that bad, but they can go rancid. The speed of the quench is similar to a light petroleum oil, and it does result in a fine hardening.

Synthetic-based oils are the state of the art when it comes to hardening. There are a few commercially available synthetic tempering oils out there, and they are very expensive, along the lines of $100 for a 5-gallon pail. If you desire to use these, by all means do so, but I have found that the lighter petroleum oils work just as well in most cases.

Petroleum-based oils are perhaps the most widely used family of hardening media. There are commercial formulae for these, as well as several tried and true homemade oils that work well for the bladesmith. This family of oil is broken down into light, medium, and heavy oil. The one most likely to be of use to the bladesmith making pattern-welded steel is the light oil.

Light oil can be made from 1 part 40-weight motor oil and 1 part automotive automatic transmission fluid (ATF). Mix well and you are set. If you desire a quicker quench, use the automatic transmission fluid alone, but I have found that you can crack some alloys by using it.

I have several other mixtures that work well, but the one mentioned above seems to be the all-around best for most applications.

HARDENING

The one "big secret" in proper hardening is an even temperature of the piece being hardened. While this seems to be no big deal, it can be, and you'd be surprised to learn how many experienced smiths there are out there who can't seem to get a piece heated evenly over its entire length. In actuality, there is no reason not to be able to do this, especially if one has

enough practice. Not only must the piece be heated evenly in length, it must be heated evenly through the thickness as well. This is called "soaking." Soaking ensures that the piece receives an even hardening of the thickness of the blade. It only takes a few seconds once an even heat is reached on the surface of the blade for it to reach through the thickness.

Mill specs for most alloys mention a soak time of several minutes to several hours for proper hardening. It seems that most mill specs deal with thicknesses of several inches of materials, not the fractions of an inch that most blades are. Face it, very few blades are thicker than 3/8 inch; in fact, most of them are 1/4 inch or less in thickness, with edges being 3/32 inch or less, so it doesn't take long for these to heat through.

Remember, the longer a blade remains at the critical temperature, the more grain growth can occur, and grain growth is very bad for the toughness and edge-holding abilities of most steels.

The Critical Temperature

The one key factor in proper hardening of steels is the proper temperature at which to quench. Here again, most mill specs tend to run a bit on the hot side of things. I have had 1045 harden at a dull red heat when water (brine) quenched, and yet I had to heat O-1 to a full cherry red before it would harden properly, so how can you tell when a particular piece is at the proper heat to harden effectively? The answer is very easy: use a magnet.

When steels reach the proper temperature for hardening, they seem to lose the properties that make them magnetic. While this is a metallurgical oddity, it works for the bladesmith. You simply touch a magnet to the blade and if it doesn't stick, it's hot enough to harden. I suggest that you use a magnet attached to a long handle to prevent burns and just tap it against the blade. Don't lay it on the blade and wait; you do not want to overheat the magnet, as this will destroy it. I simply tap and dip the magnet into some water to keep it cool. After some practice, you will be able to tell how certain combinations are going to react as far as hardening at given colors, and you will be able to tell by eye without the use of the magnet when to quench.

Hardening Water-Hard Steels

Most water-hardening steels will harden quite well in an oil bath, and I suggest that you try this first, as oil quenches are far less severe in the hardening action and easier on the steel. You don't need to shock the steel if you can prevent it. If by chance the blade did not harden in the oil, go to the brine quench.

For most billets that use high-carbon steels such as W-1, W-2, WHC, and other shallow-hardening steels, heat to a medium cherry red (approximately 1500°F), hold for a few seconds to allow for a soaking through, and then quench in the hot brine solution. I suggest that you quench point down (vertical) into the bath, as this helps prevent warping and allows for good circulation of the bath around the blade.

Oil-Hardening Steels

For 10xx series steels (1060 or higher), O-1, L-6, and most other oil-hardening alloys, use the quenching oil as described above. This results in

a very good hardening, and while oil-hardening steels do not seem to get as hard as water-hardening steels, you should never be able to tell the difference. An oil quench is a gentler quenching medium than a water/brine. Oil shocks the steel less than water/brine, and this results in less warpage, stress, and/or cracking than the harsher quenches.

To do the actual hardening, heat the blade slowly until the proper critical temperature is reached and soak until the blade is heated through. Remove the blade and quench, here again vertically. Since you are using an oil-based quench, there will be some flameup. *Do not stand over the surface or look down into the tank!* Any flameups should quickly go out by themselves. If not, they can easily be blown out. If they can't, simply cover the tank with the flameproof lid and let them burn themselves out of oxygen.

If you are worried about any possible cracking, preheat the oil to approximately 100°F. This will help to keep cracking down and lessen the chances of warpage. I suggest that you stop quenching when the oil temperature reaches 150 to 175°F. A reliable thermometer in the bath is a good idea. This way you will not even be close to the flash point of the oil, and this will help prevent severe fires or worse.

Face it; you do not need to have 25 or 30 gallons of burning oil spreading around your shop. In addition to the CO_2 extinguisher, I suggest that you keep a bucket of sand or, better yet, a couple of buckets/bags of a generic type of cat litter to prevent the spreading of any spills that may occur.

NOTE: If you are concerned about flameups, place a small piece of dry ice at the bottom of the tank or spray the CO_2 extinguisher into the tank for a second or two. Either one of these methods will drive out the air and prevent flameups. I use the dry ice method, as it constantly removes the air on the tank's surface.

Leave the blade in the quench until it cools down to the ambient temperature of the quench. No matter how much you are tempted, do not remove the blade before it has cooled fully.

When the blade is cool, remove, clean, and test for hardness. By the way, I have noticed through all the years and countless blades that if the blade was at the proper temperature for hardening, the pattern will be quite visible on the hardened section once it comes out of the quench.

How to Tell When the Blade Is Hard

The tried-and-proven method of checking a blade's hardness is on a hardness tester that uses the Rockwell C scale of hardness. This, however, is a costly piece of machinery, and it will not work all that great on a pattern-welded blade due to the fact that the laminations are so thin that the point will penetrate too deeply, even if it strikes only on a hardened layer. This will result in a false reading of hardness, and this false reading will be on the soft side and thus totally useless as far as I am concerned.

Instead, I suggest that you use the "file test." This is a rather simple test involving the use of a sharp file. Simply run the file across the edge of the blade, and if it glances off the edge without cutting, then you have some carbon migration. If it cuts slightly, you may or may not have some carbon migration, but the blade is hardened enough to cut very well. If you used 10xx series steels in the blade, then the pattern will not have a great deal of contrast.

The effect that you are looking for is a slight bite of the file. This slight cutting action means that the higher carbon laminations are hardened while the lower carbon or color laminates are not noticeably hard. This translates into the desired sawtooth cutting edge that pattern-welded steel is known for.

If the file bites too deeply and aggressively, then the blade did not harden properly. If you are certain that you did everything correctly, you will have to go to the faster water/brine quench. (Remember to clean the blade before you put it back into the forge or it may get a bit sooty from the oil burning off.)

Reheat the blade very slowly, as any additional stresses can cause it to crack or shatter. A slow heat is required whenever you are annealing any prehardened steel, no matter what form it is in.

With the blade slowly brought up to the critical temperature (make certain to check it with your magnet), remove and quench it in the hot brine and leave it in there until it is at the ambient temperature of the bath. Remove and retest.

The blade should harden. If by chance the blade cracks, well then, these things happen from time to time. Chances are the blade was not at the critical temperature when it was originally hardened, the oil was too hot, or the blade was removed before it cooled down fully. In the worse case, you did everything correctly and the blade simply cracked.

In all the years I have been doing this, I have had to use a brine quench maybe a half a dozen times on a blade, so while it is very unlikely that you will ever have to use it, it is a good thing to know how to if the occasion ever presents itself.

Once the blade is hardened you are ready to proceed with the tempering process.

TEMPERING

Tempering a pattern-welded blade is not any different than a carbon-steel blade. Actually, for most of my knives I do not really temper them; rather, I stress-relieve them in an oven set at 325 to 350°F for approximately two to three hours. This relieves just enough brittleness while keeping a high degree of hardness to help maintain a cutting edge.

For the longer blades of 9 inches or more, and most definitely for swords, I temper them like whatever steel the high-carbon laminate is. If the blade is made of 1010/1095, temper like 1095; if the blade is 1010/O-1, then temper like O-1. Of course you can always experiment and decide which way you wish to go on this, which I wholeheartedly urge you to do. There are no hard and fast rules when it comes to doing this.

So as you can see, there are no real secrets or mysteries surrounding the hardening and tempering of a pattern-welded blade, only common sense and a bit of forethought. Remember to check your temperature and quenching medium before you quench and you should be alright.

With the blade heat treated and tempered, you are ready for final grinding and finishing.

Finishing the Blade

With the blade forged, ground, and tempered, all that remains to be done is the final finish and assembly.

POLISHING

The polishing of a pattern-welded blade is a very important step. All, and I do mean *all*, grinding scratches must be removed. If there are any left, they will show up as deeply etched black lines in the surface of the blade. The blade surface must be 100-percent smooth and scratchfree. You can check the surface of the blade by using a "try etch" of either ferric chloride or diluted acid. Simply dip the blade, count to 15, remove, neutralize, and examine. If there are any rough spots or grind marks in the surface, they have to be removed or else the pattern will suffer. Go back over the blade with 220/240 grit, then proceed to 400 grit and check it again. When the blade surface is smooth and ready for polishing, buff off the slight oxidation using a sisal wheel and emory compound and then proceed with the final finish.

Remember, the smoother the surface the better. Some makers, myself included, buff the surface to a near mirror finish prior to etching because it allows for a smoother etching action of the chemicals involved. Mirror polishing is highly recommended when using pure nickel sheet, as the nickel is more or less impervious to the effects of the etchants and retains its high level of finish. Other materials etch out a duller silvery grey, making a very dramatic etch (one of the advantages of using nickel sheet).

But how far do you have to go in order to get a good etch? Well, I am in favor of a near mirror polish for all blades that use either a pure-nickel or high-nickel content alloy in their laminations. As I mentioned before, these materials do not react to most etchants and make for a beautiful contrast when highly polished. I buff these alloys with a sisal wheel and emory, followed by a hard sewn muslin wheel with 600-grit compound and then a soft sewn muslin with green chrome oxide. Remember to clean the blade after each buffing to prevent the wheel from becoming contaminated with coarser compounds.

Once again, in polishing, patience is very important. As you polish, keep inspecting the surface of the blade. You will more than likely start to see some patterning on the surface. Do not rush this process, as the longer

you take the better, especially with nickel/alloy materials.

For other materials such as combinations of 10xx series steels, W-1/W-2, WHC, and the like (including O-1 and other "rich" alloys), I polish on a belt grinder to 400 grit, then to a sisal/emory buff, and then into the etch. I suggest that you experiment and see which combination of surface polish/etches you prefer and go from there. After all, like I have said many times before, there are no absolute rules that need to be followed. This is an art, not a science.

With the blade polished, you are ready to do the final etch.

FINAL ETCH

The basic etch for most pattern-welded steels is either an acid or alkaline solution. An acid base etch is very aggressive and works best with nickel-base alloys, while an alkaline base is usually slower but results in a milder and less corrosive etch, which is, in my opinion, a prettier effect. The alkaline etch works well with most combinations, but it does take some additional time.

Surface Preparation

The surface of the blade must be 100-percent clean and free of all oils, waxes, greasy fingerprints, or any other contaminants. If the blade is not properly cleaned, then the etch will either be uneven, or, worse yet, sections or small areas will be unetched and will require a total refinishing before re-etching.

(At this point, I should state that all metalwork should be done on the piece—at least all that can be accomplished prior to soldering/attaching of the guard—before you etch the blade. This way you will help prevent any scratches, marks, or other cosmetic blemishes from affecting the blade.)

The best cleaner is acetone. Acetone is very flammable, and it can cause irritation to your skin, eyes, and mucous membranes, so take the necessary precautions. Other than that, acetone is safer than most solvents, and it does the job at hand very well.

I simply wipe the blade down using a *clean* cotton cloth saturated with acetone, being careful not to touch the blade with my bare hands, and then it goes into the etch. (You should have already constructed the etchant tanks as described in Chapter 1. If not, now is the time to do so.)

With the blade cleaned, simply wrap some wire around the tang to form a hanger to suspend it in the etching tank, degrease once more just to make sure, and place the blade point down into the etch. As mentioned before, you can use either an acid base or an alkaline etchant.

WARNING: Whenever you handle corrosive liquids, be they base or acid, always wear the proper safety clothing. This includes a rubber apron, rubber gloves, long-sleeved shirt, and safety goggles with a face shield.

If you get a spill, remember that to neutralize acids you will need an alkaline such as baking soda. To render alkalines neutral, an acid is required. I have a gallon bottle of a saturated baking soda (sodium bicarbonate) solution and a gallon of cheap, common household vinegar on hand in case I get a spill. Both are harmless to you, but they will literally save your hide in case of a spill.

Acid-Base Etchants

For the acid base, you can use diluted nitric, hydrochloric, or sulfuric acids. Remember to add acid to water, *not* water to acid, or else the acid will splatter, causing serious injuries to unprotected skin or any other part of the body.

Nitric acid etchant consists of 1 part nitric acid and 3 parts distilled water. Aqua regia (royal water) consists of 1 part nitric acid, 1 part hydrochloric acid, and 3 parts distilled water. Besides these formulae, you can use already mixed acids such as muriatic (swimming pool) acid with good results. No matter what you use, remember to *always* wear the proper safety equipment.

NOTE: Acid-base etchants seem to attack the weld lines and any other decarbonized areas more aggressively than the higher carbon content areas of the blade, so they will cause what look like cold shuts or inclusions on the blade surface if left too long in the etch. I suggest checking the blades every two to three minutes to see how the etch is progressing.

To neutralize, use a sodium bicarbonate solution in the neutralizing tank, let soak for at least five minutes, remove, rinse, wipe clean, and neutralize again before final cleaning.

Low-Acidic Etchants

The best all-around low-acidic etchant is ferric chloride (also known as printed circuit board etchant). It is available from most electronic suppliers. The etchant can be used as is, but it is, in my opinion, a bit too aggressive. I dilute the bottle (it comes in liquid form) 3 to 1 water to etchant. This will slow down the action considerably, and a slower etch is easier to control and, in my experimentations, results in a better etch.

I use the low-acidic etchant for almost all of my etching, as it works on almost every possible combination of materials.

NOTE: Alkaline-base etchants react differently than acid etches. They seem to be more aggressive on the higher carbon content areas. While they can also attack the weld lines, they do not seem to be as aggressive as the acid-based chemicals. These types of etchants work slower, so you will need to let the blade etch for a longer period of time than you would with an acid solution.

To neutralize an alkaline solution, rinse the blade in clean water and then soak in vinegar for five minutes, rinse, wipe, and clean.

The Etching Process

Regardless of the etchant chosen, it is best used cold. Warming the solutions will result in more aggressive action, and this can cause pitting, an uneven etch, and other problems that are best avoided.

It is not unusual for the blades to etch 30 to 45 minutes or longer until one gets the desired depth of etch. The longer the blade etches, the deeper the etch. Some materials, such as pure nickel (or alloys with a high percentage of nickel content), will be affected slightly or not at all, resulting in a very brilliant etch with considerable topography between layers. This topography will be a benefit later when the final finishing is completed.

To etch the blades, they should be suspended point down (vertical) into

the bath. Laying the blades down into a bowl will not allow for good circulation of the etchant, and good circulation is a must for an even etch. I do a slight etch of approximately 30 seconds, then remove the blade from the bath to see if the etchant is biting evenly. If not, the blade is rinsed off, recleaned, placed back in the etch, and checked again after another 30 seconds.

If the blade is an even grey color, the etch is working. If there are any shiny spots, streaks, or other unetched areas, clean the blade and then place it back in the etch. If all is well, let the blade soak in the etchant for about 15 minutes. Longer periods of time may be required, but it is no problem to simply put the blade back into the bath for another 5 minutes.

As you gain experience, you will be able to tell how long certain materials need to etch properly. On most of my blades, I etch for 30 to 75 minutes, depending upon the materials used.

As the blade etches, a small amount of the surface is dissolved, leaving a black gummy film on the blade's surface. It is this dissolving action that causes the pattern to become visible. The etchants work on different materials at different rates, and it is this difference that you see when looking at the pattern.

When you are satisfied with the etch, rinse the blade thoroughly and then neutralize it. This neutralization will prevent further etching and help prevent rust. To neutralize an acid-base etch, use a baking soda solution; for an alkaline etch, use vinegar.

With the blade neutralized, clean it once more, this time using a solution of trisodium phosphate (TSP). (Be sure to wear rubber gloves, as this can really have a nasty effect on your hands.) Dry completely and then oil with a water-displacing oil.

If you wish to have a smoother finish, coat the blade with a light oil and sand the surface lightly with 600-grit wet/dry sanding paper. Be very careful or you may start to erase the pattern. You only need a few strokes to smooth the surface and bring out the pattern even more. This will also help to remove any surface coating that may remain from the etch.

Of course you can leave the pattern as is or simply buff the blade lightly instead of hand rubbing, or you can hand rub and then buff lightly. Regardless of what you do, keep the blade oiled in order to prevent rusting.

If you are going to the power buff, beware: you can easily overdo it, erasing an etched section, causing a shiny center spine on a double-edged or fullered blade, or, even worse, causing surface dips. I suggest that you experiment on some scraps before you decide on doing something "new."

No matter how you etch or what you etch in, remember that a slower etch is a prettier etch. You shouldn't try to rush the process, since the etch is the final step to bringing out the beauty of the steel—which is what it's all about, isn't it?

BLUING

On blades that use pure nickel, the blade can be blued after etching and prior to hand rubbing. This will bring out some very dramatic contrasts. I have tried this on other materials, and while it helps to bring out the watering, it works best on a blade with pure nickel in its makeup.

I use a hot (285°F) bluing bath of saturate sodium hydroxide, which is

what I recommend. I have tried the cold-application types of bluing (the types used to touch up firearms), but I have found them very difficult to apply evenly without spotting or streaking. If you care to try applying the cold-blue solution, make certain that the blade's surface is absolutely clean of all oils, waxes, and other contaminants. Follow the manufacturer's directions carefully and you should get satisfactory results, but nothing like what you would get with the hot bath type of blue.

Hot bath bluing is a very specialized process involving some highly caustic and very toxic chemicals, namely sodium hydroxide.

WARNING: The following information is presented for your education only. No one should try this on his own without proper professional training by a competent and experienced gunsmith or metal finisher.

The hot bath blue process, while hazardous, it is not beyond the capabilities of most reasonably intelligent people. One must always remember to act responsibly and to *always* follow the proper safety procedures. Again, this process should be done only by a properly trained individual.

The equipment needed will be three nongalvanized, nonstainless steel iron blue tanks. Two of these will need to be heated, one for the hot cleaner, the other for the blue salts. The third tank is a cold rinse tank filled with plain water.

The hot cleaner is usually a solution of trisodium phosphate held at a temperature of approximately 165 to 185°F.

The blue salts tank must be kept between 275 and 290°F. If the temperature exceeds 295°F, then the salts can be burned and must be replaced. If burned salts are used, the metal will come out a rusty reddish brown, not an even, lustrous blue-black.

Disposing of these corrosive salts must be done in compliance with all local, state, and federal laws pertaining to hazardous chemical disposal. This includes the possibility of needing a license to even purchase or possess these chemicals.

The proper safety equipment must be worn. This includes but is not limited to full faceshield and eye goggles, rubber apron, rubber gloves, and a long-sleeved shirt. Sodium hydroxide is very caustic and very base. A jug of vinegar should be kept close at hand to neutralize any spills *immediately!*

The salts are mixed as per the instructions and maintained at the proper temperature. The cleaner is also maintained at the desired temperature. The piece to be blued is degreased and placed into the cleaner bath for up to an hour. The cleaner will remove any minute particles of contaminants.

NOTE: At no time should brass, copper, zinc, tin, aluminum, or any other nonferrous metal be introduced into the bluing bath. This will result in the mildest "poisoning" of the bath, thus making replacement of the salts a must. In the worst case, a severe chemical reaction will spray exceedingly hot sodium hydroxide all over the area.

Once the piece is clean, it is placed into the cold rinse, allowed to cool, and then removed.

With the piece rinsed and before the surface dries, it is placed into the blue salts, making certain that it is totally immersed. It is allowed to remain in the slat bath for 30 to 60 minutes, depending upon the formula used.

After the allotted time has passed, the piece is removed and once again placed into the cold rinse, rinsed clean of the salts, removed, dried quickly, and then heavily oiled with a water-displacing oil.

These are the absolute basics of hot bath bluing. I must say again that the above information is for educational purposes only and in no way should be construed to be proper instruction in this process in any way, shape, or form. Hot bluing is dangerous and should be done only by a properly trained individual. If you want to do your own bluing, I suggest that you contact a local gunsmith or metal finishing company and take it from there.

Hot bluing is a very durable finish that can enhance the beauty of a pattern-welded blade, especially if a high-nickel alloy is used. It can also be used to finish various mild and high-carbon steels to a lustrous, deep black finish that can be quite dramatic.

FINAL ASSEMBLY

With the blade etched (and/or blued), you will need to *lightly* file the ricasso/tang joint to expose a clean, unaffected surface for the solder to joint to. Do not worry about the sides (flats) of the blade, as they should solder nicely. In fact, it can get to be a little hard to deal with as the solder could flow up the pattern a bit due to capillary action. But this is nothing to really worry about, since it is easy to clean off by simply lightly buffing the affected area.

Since you are now more or less finished with the pattern-weld process, you are ready to do the final assembling.

In order to protect the blade during the remaining steps in the assembly of the piece, I suggest that you oil the surface lightly and wrap it in electrical tape. The oil will help prevent any rust or oxidation from occurring, and the tape will help protect the blade from any errant scratches or marring. Once the final assembly is accomplished, the tape can be removed rather easily. Any remaining adhesive on the blade is best removed by using a little acetone on a clean, soft cotton cloth. I strongly suggest using cotton, as the acetone could react with another fabric, causing it to break down, and that could really mess up the cleaning process.

After the blade is wiped clean, lightly oil and you are done.

■ ■ ■

A pattern-welded blade can be a very beautiful and intriguing thing to look at. The types, patterns, and combinations are nearly endless, and one is only limited by one's imagination.

A well-forged, perfectly welded blade is a testament to the smith's ability and patience. Some patterns are simple, while others are very complicated. No matter which patterns you prefer to make, they all deserve your best effort and care, as infinite care is a mark of the craftsman.

It is this craftsmanship that makes up the pattern-welded blade. More than simply laminated and twisted steel and iron, a pattern-welded blade is a very special blade, one that reflects the abilities of the one who made it. It deserves your best effort, as it will be the showcase of your skill to all who see it.

You have undertaken the challenge of the ancient smiths, to work with hot steel and iron, to express yourself with toil and labor. I hope that you have found this tome to be of some worth to you in your search for the perfect blade.

Weights, Measures, and Compounds

The tables below can be of great help when figuring the amount of materials to be used for a given project and when purchasing needed supplies:

Fraction/Decimal/Millimeter Equivalents

Fraction	Decimal	Millimeter
1/64	.0156	0.396
1/32	.0312	0.793
3/64	.0468	1.190
1/16	.0625	1.587
5/64	.0781	1.984
3/32	.0937	2.381
7/64	.1093	2.778
1/8	.1250	3.175
9/64	.1406	3.571
5/32	.1562	3.968
3/16	.1875	4.762
13/64	.2031	5.159
7/32	.2187	5.556
15/64	.2343	5.953
1/4	.2500	6.350
17/64	.2656	6.746
9/32	.2812	7.143
19/64	.2958	7.540
5/16	.3125	7.937
21/64	.3281	8.334
11/32	.3437	8.731
23/64	.3593	9.128
3/8	.3750	9.525
25/64	.3906	9.921
13/32	.4062	10.318
27/64	.4218	10.715
7/16	.4375	11.112

29/64	.4531	11.509
15/32	.4687	11.906
31/64	.4843	12.303
1/2	.5000	12.700

Comparison of Standard Metal Gauges

The below thicknesses are in 1/1000 of an inch.

Gauge No.	Brown & Sharpe (American Wire)	British Imperial Standard	Millimeter
1	0.289	0.300	7.346
2	0.257	0.276	6.543
3	0.229	0.252	5.829
4	0.204	0.232	5.189
5	0.181	0.212	4.618
6	0.162	0.192	4.111
7	0.144	0.176	3.670
8	0.128	0.160	3.264
9	0.114	0.145	2.906
10	0.101	0.128	2.588
11	0.090	0.116	2.304
12	0.080	0.104	2.052
13	0.071	0.092	1.829
14	0.064	0.080	1.629
15	0.057	0.072	1.450
16	0.050	0.064	1.290
17	0.045	0.056	1.151
18	0.040	0.048	1.024
19	0.035	0.040	0.912
20	0.031	0.036	0.813
21	0.028	0.032	0.724
22	0.025	0.028	0.643
23	0.022	0.024	0.574
24	0.020	0.022	0.511
25	0.017	0.020	0.445
26	0.015	0.018	
27	0.014	0.016	
28	0.012	0.014	
29	0.011	0.013	
30	0.010	0.012	

Weights of 1095 Steel Sheet Per Square Foot

28 ga. (0.0149″)	0.625 lb. per sq. ft.
26 ga. (0.0179″)	0.750 lb. per sq. ft.
24 ga. (0.0239″)	1.00 lb. per sq. ft.
22 ga. (0.0299″)	1.25 lb. per sq. ft.
20 ga. (0.0359″)	1.50 lb. per sq. ft.

18 ga. (0.0478″)	2.00 lb. per sq. ft.
16 ga. (0.0598″)	2.50 lb. per sq. ft.
14 ga. (0.0747″)	3.125 lb. per sq. ft.

Weights of Rectangular Steel Bars Alloy 5160

1″ x .250	0.84 lb. per ft.
1.25″ x .250	1.03 lb. per ft.
1.5″ x .204	1.03 lb. per ft.
.214	1.08 lb. per ft.
.237	1.20 lb. per ft.
.262	1.32 lb. per ft.
1.75″ x .204	1.20 lb. per ft.
.214	1.26 lb. per ft.
.237	1.39 lb. per ft.
.262	1.54 lb. per ft.

Weights of 1095 Rectangular Bar Stock

1″ x .125	0.44 lb. per ft.
.187	0.64 lb. per ft.
.250	0.85 lb. per ft.
1.25″ x .125	0.54 lb. per ft.
.187	0.80 lb. per ft.
.250	1.07 lb. per ft.
1.5″ x .125	0.64 lb. per ft.
.187	0.94 lb. per ft.
.250	1.35 lb. per ft.

Weights of Carbon Steel Bars

Some alloys are available in only square, round, or hexagonal cross sections. The table below will give you a basic guide to how much these bars weigh. Weights are in pounds per foot of length.

Size	Rounds	Squares	Hex.	Oct.
1/4″	0.167	0.213	0.184	0.176
5/16″	0.261	0.332	0.288	0.275
3/8″	0.376	0.478	0.414	0.396
7/16″	0.511	0.651	0.564	0.539
1/2″	0.668	0.850	0.737	0.704
9/16″	0.845	1.076	0.932	0.891
5/8″	1.040	1.328	1.150	1.100
11/16″	1.260	1.607	1.393	1.331
3/4″	1.500	1.913	1.658	1.581
13/16″	1.760	2.245	1.944	1.859
7/8″	2.040	2.603	2.256	2.157
15/16″	2.350	2.988	2.588	2.476
1″	2.670	3.400	2.944	2.817

1-1/16"	3.010	3.838	3.324	3.180
1-1/8"	3.380	4.303	3.727	3.565
1-3/16"	3.770	4.795	4.152	3.972
1-1/4"	4.170	5.314	4.601	4.401
1-5/16"	4.600	5.857	5.072	4.852
1-3/8"	5.050	6.428	5.567	5.352
1-7/16"	5.517	7.026	6.085	5.820
1-1/2"	6.010	7.650	6.625	6.338
1-9/16"	6.519	8.301	7.189	6.887
1-5/8"	7.050	8.978	7.775	7.438
1-11/16"	7.604	9.682	8.385	8.021
1-3/4"	8.180	10.414	9.018	8.626

Decimal Sizes of Numbered Twist Drills

No.	Size	No.	Size	No.	Size	No.	Size
1	0.228	21	0.159	41	0.096	61	0.039
2	0.221	22	0.157	42	0.093	62	0.038
3	0.213	23	0.154	43	0.089	63	0.037
4	0.209	24	0.152	44	0.086	64	0.036
5	0.205	25	0.149	45	0.082	65	0.035
6	0.204	26	0.147	46	0.081	66	0.033
7	0.201	27	0.144	47	0.078	67	0.032
8	0.199	28	0.140	48	0.076	68	0.031
9	0.196	29	0.136	49	0.073	69	0.029
10	0.193	30	0.128	50	0.070	70	0.028
11	0.191	31	0.120	51	0.067	71	0.026
12	0.189	32	0.116	52	0.063	72	0.025
13	0.185	33	0.113	53	0.059	73	0.024
14	0.182	34	0.111	54	0.055	74	0.022
15	0.180	35	0.110	55	0.052	75	0.021
16	0.177	36	0.106	56	0.046	76	0.020
17	0.173	37	0.104	57	0.043	77	0.018
18	0.169	38	0.101	58	0.042	78	0.016
19	0.166	39	0.099	59	0.041	79	0.014
20	0.161	40	0.098	60	0.040	80	0.013

Decimal Sizes of Lettered Drills

Letter	Size	Letter	Size
A	0.234	N	0.302
B	0.238	O	0.316
C	0.242	P	0.323
D	0.246	Q	0.332
E	0.250	R	0.339
F	0.257	S	0.348
G	0.261	T	0.358
H	0.266	U	0.368

I	0.272	V	0.377	
J	0.277	W	0.386	
K	0.281	X	0.397	
L	0.290	Y	0.404	
M	0.295	Z	0.413	

The Elements and Their Abbreviations

Being able to properly identify what is in a given alloy will enable you to decide whether or not you want to use it for a given purpose. The table below is the standard table of elements to help you in reading mill melt spec sheets.

Name	Symbol	Atomic Number
Actinium	Ac	89
Aluminum	Al	13
Americium	Am	95
Antimony	Sb	51
Argon	Ar	18
Arsenic	As	33
Astatine	At	85
Barium	Ba	56
Beryllium	Be	4
Bismuth	Bi	83
Boron	B	5
Bromine	Br	35
Cadmium	Cd	48
Calcium	Ca	20
Carbon	C	6
Cerium	Ce	58
Cesium	Cs	55
Chlorine	Cl	17
Chromium	Cr	24
Cobalt	Co	27
Columbium	Cb	41
Copper	Cu	29
Curium	Cm	96
Dysprosium	Dy	66
Erbium	Er	68
Europium	Eu	63
Fluorine	F	9
Francium	Fa	87
Gadolinium	Gd	64
Gallium	Ga	31
Germanium	Ge	32
Gold	Au	79
Hafnium	Hf	72
Helium	He	2

Holmium	Ho	67
Hydrogen	H	1
Illinium	Il	61
Indium	In	49
Iodine	I	53
Iridium	Ir	77
Iron	Fe	26
Krypton	Kr	36
Lanthanum	La	57
Lead	Pb	82
Lithium	Li	3
Lutetium	Lu	71
Magnesium	Mg	12
Manganese	Mn	25
Mercury	Hg	80
Molybdenum	Mo	42
Neodymium	Nd	60
Neon	Ne	10
Neptunium	Np	93
Nickel	Ni	28
Nitrogen	N	7
Osmium	Os	76
Oxygen	O	8
Palladium	Pd	46
Phosphorus	P	15
Platinum	Pt	78
Plutonium	Pu	94
Polonium	Po	84
Potassium	K	19
Praseodymium	Pr	59
Protactinium	Pa	91
Radium	Ra	88
Radon	Rn	86
Rhenium	Re	75
Rhodium	Rh	45
Rubidium	Rb	37
Ruthenium	Ru	44
Samarium	Sm	62
Scandium	Sc	21
Selenium	Se	34
Silicon	Si	14
Silver	Ag	47
Sodium	Na	11
Strontium	Sr	38
Sulfur	S	16
Tantalum	Ta	73
Technetium	Tc	43
Tellurium	Te	52
Terbium	Tb	65
Thallium	Tl	81

Thorium	Th	90
Thulium	Tm	69
Tin	Sn	50
Titanium	Ti	22
Tungsten	W	74
Uranium	U	92
Vanadium	V	23
Xenon	Xe	54
Ytterbium	Yb	70
Yttrium	Y	39
Zinc	Zn	30
Zirconium	Zr	40

Before the standardization of elemental names and atomic numbers, there were the "old names" of compounds and elements that were used from day to day, even in the more scientific circles. These formulae are still around, so as an aid to the modern reader, I have included the old names for the more common compounds and elements from the "good old days."

Old Name	Chemical Composition
Acid of Potassium Sulphate	Potassium Bisulfate
Acid of Sugar	Oxalic Acid
Alcali Volatil	Ammonium Hydroxide
Alcohol Sulphurus	Carbon Disulfide
Alumina	Aluminium Hydroxide
Ammonia	Ammonium Hydroxide
Antimony Black	Antimony Trisulfide
Antimony Bloom	Antimony Trioxide
Antimony Glance	Antimony Trisulfid
Antimony Red	Antimony Oxysulfide
Antimony Vermillion	Antimony Oxysulfide
Aqua Fortis	Nitric Acid
Agua Regia	Nitric and Hydrocloric Acids
Baking Soda	Sodium Bicarbonate
Bitter Salts	Magnesium Sulfate
Bichromate of Potash	Potassium Dichromate
Black Oxide of Manganese	Manganese Dioxide
Blue Copperas	Copper Sulfate
Blue Salts	Nickel Sulfate
Blue Stone	Copper Sulfate
Blue Vitrol	Copper Sulfate
Bone Ashes	Impure Calcium Carbonate
Bone Black	Animal Charcoal
Borax	Sodium Borate
Brimstone	Sulphur
Butter of Antimony	Antimony Trichloride
Butter of Tin	Stannic Chloride Hydrated
Butter of Zinc	Zinc Chloride

Calomel	Mercurous Chloride
Caustic Soda	Sodium Hydroxide
Chile Nitre	Sodium Nitrate
Chile Saltpeter	Sodium Nitrate
Chromic Acid	Chromium Trioxide
Copperas	Ferrous Sulfate
Corrosive Sublimate	Mercuric Chloride
Corundum	Aluminium Oxide
Cream of Tartar	Potassium Bitartrate
Dragon's Blood	Cannet Root
Ferro Prussiate	Potassium Ferricyanide
Flores Martis	Anhydrous Ferric Chloride
Flowers of Sulphur	Sulphur
Gallic Acid	3,4,5, Trihydroxybenzoic Acid
Grain Alcohol	Ethyl Alcohol
Green Vitrol	Ferrous Sulfate
Hard Oil	Boiled Linseed Oil
Horn Silver	Silver Nitrate
Iron Perchloride	Ferric Chloride
Iron Pernitrate	Ferric Nitrate
Iron Protochloride	Ferrous Chloride
Iron Persulphate	Ferric Sulfate
Iron Sulfate	Ferrous Sulfate
Ivory Black	Burnt, Ground Ivory
Jeweler's Etchants	3 g. Silver Nitrate
	3 g. Nitric Acid
	3 g. Mercurous Nitrate
	100 cc Distilled Water
Killed Spirits	Zinc Chloride
Lime	Calcium Oxide
Liver of Sulphur	Potassium Sulfide
Lunar Caustic	Silver Nitrate
Muriate of Mercury	Mercuric Chloride
Muratic Acid	Hydrochloric Acid
Nitre	Potassium Nitrate
Nordhausen Acid	Fuming Sulphuric Acid
Oil of Mars	Deliquescent Anhydrous Ferric Chloride
Oil of Vitrol	Sulfuric Acid
Orthophosphoric Acid	Phosphoric Acid
Oxymuriate of Mercury	Mercuric Chloride
Oxymuriate of Potassium	Potassium Chlorate
Peach Ash	Potassium Carbonate
Pearl Ash	Potassium Carbonate
Plumbago	Graphite
Potash	Potassium Carbonate
Prussic Acid	Hydrocyanic Acid
Purple Crystals	Potassium Permanganate
Quick Silver	Mercury

Red Prussate of Potash	Potassium Ferrocyanide
Sal Ammoniac	Ammonium Chloride
Salt of Hartshorn	Ammonium Carbonate
Salt of Lemon	5% Sol. Potassium Acid Oxalate
Salt of Sorrel	5% Sol. Potassium Acid Oxalate
Salt of Tartar	Potassium Carbonate
Salt of Vitrol	Zinc Sulfate
Salt of Worm Wood	Potassium Carbonate
Saltpeter	Potassium Nitrate
Sal Volatile	Ammonium Carbonate
Slaked Lime	Calcium Hydroxide
Soda	Sodium Carbonate
Spencer's Acid	3 g. Silver Nitrate
	3 g. Nitric Acid
	3 g. Mercurous Nitrate
	100 cc Distilled Water
Spirits of Hartshorn	Ammonia Water
Spirits of Salt	Hydrochloric Acid
Spirits of Nitrous Ether	Ethyl Nitrate
Spirits of Wine	Ethyl Alcohol
Sugar of Lead	Lead Acetate
Sulphuric Ether	Ethyl Ether
Sweet Spirits of Nitre	Ethyl Nitrate Spirit
Tetrachloromethane	Carbon Tetrachloride
Tincture Ferric Chloride	Ferric Chloride/Ethyl Alcohol
Tincture of Steel	Ferric Chloride/Ethyl Alcohol
Tin Salt	Stannous Chloride
Verdigris	Copper Acetate
Vitrol	Sulfuric Acid
Water Glass	Potassium Silicate,
	Sodium Silicate
Yellow Prussate of Potash	Potassium Ferrocyanide

Bibliography

American Society of Metals. *Worldwide Guide to Equivalent Irons and Steels.* ASM Press: 1979.

Figiel, Loe S. *On Damascus Steel.* Atlantis Arts Press: 1991.

Hrisoulas, Jim. *The Complete Bladesmith*. Paladin Press, Boulder, CO: 1987.

— . *The Master Bladesmith*, Paladin Press, Boulder, CO: 1991.

Oakeshott, Ewart. *Records of the Medieval Sword*. Boydell Press, Woodbridge, England: 1991.

Roesdahl, Else, and Wilson, David M. *From Viking to Crusader*. Rizzoli International Publications, New York, NY: 1992.

Smith, Cyril Stanley. *A History of Metallography*. MIT Press, Cambridge, MA: 1960.

Untracht, Oppi. *Metal Techniques for Craftsmen*. Doubleday & Co., Garden City, NY: 1968.

Printed in the USA
CPSIA information can be obtained
at www.ICGtesting.com
LVHW011117131023
760817LV00019B/1433